SAINT PAUL

SAINT PAUL

A Screenplay

PIER PAOLO PASOLINI

Translated and Introduced by
Elizabeth A. Castelli

Foreword by Alain Badiou

Afterword by Ward Blanton

V
VERSO
London • New York

This English-language edition first published by Verso 2014
Translation © Elizabeth A. Castelli 2014
Foreword translation © David Fernbach 2014
Introduction © Elizabeth A. Castelli 2014
Afterword © Ward Blanton 2014
First published in Italian as *San Paolo*
© Einaudi 1977
Foreword first published in the French edition, *Saint Paul*
Foreword © Editions Nous 2013

All rights reserved

The moral rights of the authors have been asserted

1 3 5 7 9 10 8 6 4 2

Verso

UK: 6 Meard Street, London W1F 0EG
US: 20 Jay Street, Suite 1010, Brooklyn, NY 11201
www.versobooks.com

Verso is the imprint of New Left Books

ISBN-13: 978-1-78168-288-3 (HBK)
eISBN-13: 978-1-78168-289-0 (US)
eISBN-13: 978-1-78168-658-4 (UK)

British Library Cataloguing in Publication Data
A catalogue record for this book is available from the British Library.

Library of Congress Cataloging-in-Publication Data
A catalog record for this book is available from the Library of Congress.

Typeset in Fournier by MJ & N Gavan, Truro, Cornwall
Printed in the US by Maple Press

Contents

Foreword by Alain Badiou vii

Acknowledgements xiii

Introduction: Translating Pasolini Translating Paul
by Elizabeth A. Castelli xv

Plan for a Film about Saint Paul 1

Outline of a Screenplay for a Film about Saint Paul
(in the Form of Notes for a Production Director) 11

Note on the Text 109

*Afterword: Appropriation's Excess, Paul of Tarsus for an
Age of the Capitalization of Mastery* by Ward Blanton 111

Foreword

Alain Badiou

It is well known that the Christian reference played a role of primary importance in the formation of Pasolini's thought, despite (or because of) the sexual and transgressive violence that inspired his personal life and bestowed a particular coloration on his communist political choices. In a certain sense, it was a sacrifice bordering on the sacred – the mysterious death of his brother, an Italian partisan, probably killed by the Yugoslav resistance at the moment of Liberation – that led both to his view of the judgement one can make on History, and to the severity he displayed, from the late 1950s on, towards the Italian Communist Party. Basically, the PCI was guilty in his eyes of having allowed the young people of the Resistance to die without legitimate heirs or genuine political paternity, which led also to abandoning to their fate the young proletarians of the modern housing estates. Among other texts, the broad and splendid poem *Vittoria* presents the history of this denial, suggesting in the background the denial of St Peter: by denying Christ, Peter had shown too much attachment to his own safety; and against Paul, at Antioch, too much attachment to the

old rituals that limited the universality of the message. It was Peter, rather than Paul, who prefigured the sclerosis of the Church, and likewise that of the PCI. Consider this passage, which stigmatizes the 'realism' of political parties, caught in the 'mysterious debate with Power' and deaf to the voice of young people in revolt:

> ... Joyous
> with a joy that rejects any second thought
> is this army – blind in the blind
> sun – of young dead, who come
> and who await. If their father, their leader,
> leaves them alone in the whiteness of the hills, in the peaceful
> plains – absorbed in a mysterious debate
> with Power, enchained to its dialectic
> that history forces him unceasingly to reform –
> quite gently, in the barbarous hearts
> of the sons, hatred gives way to love of hate.

More generally, Pasolini relentlessly confronted the forms that a life devoted to the naked truth of the subject could take vis-à-vis the avatars of the Passion and the pitfalls of holiness. If we compare him, for example, with Bataille, it is easy to maintain that it is with much more sincerity, exposure to risk, and poetic gift that Pasolini made the dialectic of abjection and the sublime his own. If we compare him with Genet, we have – though in this case equal in terms of quality – the whole difference between sublimation by way of poetry (or the cinema) and sublimation by way of prose (and the theatre). The former orients itself towards origins, fables and myths, the figures of history (Oedipus, Christ, St Paul, Dante, Gramsci) the latter to an intimate tale mingled with and borne up, as it were, by the latent breath of the history of peoples: underclass prison angels, prostitutes, blacks, Palestinians... But in every case, on the horizon of meditation lies the question of religion. Not as a possibility still open, there is no question of believing in it, but

as a poetic and historical paradigm of the possibility of scathing confrontation, at the heart of individual and collective existence, with the implacable truths that religion can express and with the meaning it may or may not receive from the world such as it is.

It is indeed this rift between meaning and truth that is at issue in the figure of Oedipus, as Pasolini's very fine film restores him: as soon as one discovers the truth (murder of the father, incest with the mother), the only meaning that life still finds is in blindness and death. But this is also the figure of Christ: so that truth will come to the desert world of men, God must present the absurdity of his own torment. Hence the power of the film that Pasolini drew from the Gospel According to St Matthew. And is it not tempting to see Pasolini's own death, which remains so obscure, as the Passion of true desire fulfilled in sacrifice under the insensate knife of the person this desire encounters?

It is only too natural, in this context, that St Paul should have been a tutelary figure for Pasolini. He saw him, in fact, as the first embodiment of the conflict between political truth (communist emancipation being the contemporary form of salvation), and the meaning this could assume in the weight of the world. In our world, in fact, truth can only make its way by protecting itself from the corrupted outside, and establishing, within this protection, an iron discipline that enables it to 'come out', to turn actively towards the exterior, without fearing to lose itself in this. The whole problem is that this discipline (of which Paul is here the inventor under the name of the Church, like Lenin for communism under the name of the Party), although totally necessary, is also tendentially incompatible with the pureness of the True. Rivalries, betrayals, struggles for power, routine, silent acceptance of the external corruption under the cover of practical 'realism': all this means that the spirit which created the Church no longer recognizes in it, or only with great difficulty, that in the name of which this was created.

Paul is one of the possible historical names of the tension between fidelity to the founding event of a new cycle of the True (metaphorically, the resurrection of Christ; actually, the communist revolution) and the rapid exhaustion, under the cross of the world, of the pure subjective energy (holiness, or totally disinterested militancy) that the concrete realization of this fidelity would demand.

Pasolini wanted to make a major film on the dialectical character of Paul. This would essentially be a sequel to his film on the Passion of Christ: the history of the Church, which, as guardian of the meaning of this Passion, propagates and perpetuates its truth effects, and also the history of the failure of this guardianship. He did not find financing for this film. But we have a very detailed scenario of it, a scenario that in my view is in itself a literary work of the first magnitude.

As he did in his *Oedipus Rex*, Pasolini juxtaposed the ancient reference with the contemporary, but in a very different manner. The action of *Saint Paul*, in fact, is situated completely in the contemporary world, whereas in *Oedipus Rex*, the contemporary drama with the mother 'duplicates' the connected visibility of the legendary tale. What pertains totally to antiquity in *Saint Paul* is quite simply, and exclusively, the apostle's own words, the text.

We might say that in *Oedipus* we have a 'distribution of the sensible', in the meaning that Jacques Rivière gave this expression, the history – the legendary text – being distributed between two different regimes of visibility, the ancient and the modern. In *Saint Paul*, on the other hand, the sensible is homogeneous (it belongs to our world), while a large part of the intelligible (what is thought and uttered), being drawn from the epistles of Paul or the Acts of the Apostles, is a reproduction of the antique.

Pasolini's wager, therefore, is that the truth of which St Paul is the divided bearer, the sacrificed militant, can make sense in the

Foreword

world of today, thus proving the latent universality of his thought. We can see the United States in place of Rome, the intellectual snobs of Rome (whom Pasolini hated) in place of the philosophers of the Athenian agora, or echoes of collaboration and the Resistance in France: Paul's text crosses all these circumstances intact, as if it had foreseen them all.

What this meant for Pasolini was that all corruptions resemble one another, declining empires and their exhausted valets resemble each other, and the betrayers of all truths exposed to lack of meaning all wear the same mask.

With stupefying virtuosity, Pasolini manages this very risky construction, in which the invariance of a text that bears truth – the invariance, basically, of the Idea – is shown, in the Passion it supports, as having to find an acceptable meaning in unappropriated worlds.

This scenario should be read, not as the unfinished work that it was, but as the sacrificial manifesto of what constitutes, here as elsewhere, the real of any Idea: the seeming impossibility of its effectuation. Pasolini was scarcely optimistic as to the possible metamorphosis of this impossible-real in a world that would finally have meaning. Do we have reasons to be more optimistic than he was? The existence of Pasolini's poems and films is certainly one of these reasons, as optimism has never been anything but a pessimism overcome by its own subject, in the work of universal significance that, against all expectation, this has produced.

Acknowledgements

Work on this translation was supported by a grant from the Center for Translation Studies at Barnard College, thanks to an umbrella grant from the Mellon Foundation. I wish to express my special thanks to the Center's director, Peter Connor, for his encouragement of this project. Dr. Rita Lucarelli of the University of Bonn reviewed the translation and made several helpful suggestions and corrections; she was also an enthusiastic supporter of this project. I presented portions of this translation to seminars and audiences at the Center for Religion and Media at New York University, the Program in Scripture and the Arts at Boston University, and the University Seminar on the New Testament at Columbia University, and I benefited greatly from the discussions that took place on those occasions. I wish also to thank Ward Blanton of the University of Kent for his collaboration on this project. And finally to Verso Books for acquiring the English-language rights for this publication.

Introduction: Translating Pasolini Translating Paul

Elizabeth A. Castelli

Ogni bestemmia è una parola sacra.
[Every blasphemy is a sacred word.]
Pier Paolo Pasolini

In May 1966, Pier Paolo Pasolini – poet, novelist, translator, critic, screenwriter, filmmaker, cultural theorist, polemicist, and artist-of-the-self – wrote a letter to Don Emilio Cordero, the director of Sampaolofilm in Rome, to accompany 'these few little pages' [*queste poche paginette*] that contained the initial treatment for the film about Saint Paul that Pasolini hoped to make. 'I have the impression', Pasolini wrote, 'that, for the person who reads it unprepared, this project will cause a little dizziness ... As far as I am concerned, I am beginning to feel toward this project that exclusive and possessed love that binds me to my work, when doing it begins to become irrepressible.'[1] Cordero's response to

1 Pier Paolo Pasolini, 'A Don Emilio Cordero – Roma, maggio 1966', in *Lettere, 1955–1975*, ed. Nico Naldini (Turin: Einaudi, 1988), 615; see

Pasolini was enthusiastic about the project itself but negative about the practical possibilities of moving forward with it at the time: 'I wanted and hoped so much to make a film about Saint Paul with you. Unfortunately, the moment has not yet arrived ... I am sure ... that the project designed by you is valid and of great interest'.[2]

The following month, Pasolini responded with considerable disappointment, asking whether he ought to resign himself to not making the film, whether the project might be possible in two or three years' time, 'or should I think that my project and my person are considered a risk and that therefore no real possibility exists even in the distant future?'[3] Don Cordero responded with a Latin quotation adapted from Paul's first letter to the Thessalonians – 'do not weep like those who do not have hope' [*nolite flere sicut qui spem non habent*] (1 Thess. 4:13), and encouraged Pasolini, despite the practical obstacles involved in making the film at that moment, not to give up.[4] Two years later, Pasolini wrote again to Don Cordero, referring to the film now as 'our THEOLOGICAL FILM', and gesturing toward the project's most foundational

also Pier Paolo Pasolini, *Vita attraverso le lettere*, ed. Nico Naldini (Turin: Einaudi, 1994), 270: 'Ho l'impressione che, a chi lo legga impreparato, questo progetto faccia venire un po' il capogiro ... Quanto a me, comincio a sentire verso questo progetto quell'amore esclusivo e invasato che mi lega alle mie opera, quando il farle comincia a diventare intrattenibile.' [Unless otherwise attributed, all translations from Italian are mine.]

2 Pasolini, *Lettere, 1955–1975*, 615–16: 'Ho desiderato e sperato tanto di fare un film su San Paolo con Lei. Purtroppo questo momento non è ancora giunto ... Sono sicuro ... che il progetto da Lei studiato sia valido e di grande interesse ...'

3 Pier Paolo Pasolini, 'A Don Emilio Cordero – Roma' [postmarked Rome, 25 June 1966], *Lettere, 1955–1975*, 619: 'Devo proprio rassegnarmi a non fare il film per sempre? Oppure c'è ancora qualche possibilità fra due or tre anni? O devo pensare che il mio progetto e la mia persona sono considerati un rischio, e che quindi non esiste nessuna reale possibilità anche in un futuro piú lontano?'

4 Pasolini, *Lettere, 1955–1975*, 619.

ideological distinctions and cultural critique: 'In fact here the story of two Pauls is narrated: the saint and the priest ... I am all for the saint, while I am certainly not very tender toward the priest ... [The screenplay leaves] the spectator to choose and to resolve the contradictions and to establish whether this THEOLOGICAL FILM be a hymn to Holiness or to the Church.'[5] If Don Cordero responded to this letter, the correspondence is not preserved, though in the end the project was never realized and the film remained unmade.

This exchange of letters contains the first references to the Saint Paul project in Pasolini's writings, one of several projects that never came to completion during his lifetime. Despite the ultimate failure of the project, there is plenty of testimony, especially in interviews, newspaper articles, and other parts of the Pasolini archive, showing that Pasolini remained deeply committed to making the film.[6] Indeed, its subject matter – the

5 Pier Paolo Pasolini, 'A Don Emilio Cordero – Roma, 9 giugno 1968', in *Lettere, 1955–1975*, 639: 'Infatti qui si narra la storia di due Paoli, il santo e il prete ... io sono tutto per il santo, mentre non sono certo molto tenero con il prete ... lasciando libero lo spettatore di scegliere e di risolvere le contraddizioni: e di stabilire se questo FILM TEOLOGICO sia un inno alla Santità o alla Chiesa.'

6 On the one hand, in a short column published in January 1969, Pasolini seems to have already resigned himself to the fact that the film would not be made. See Pier Paolo Pasolini, 'La mia provocatoria indipendenza', in *Saggi sulla politica e sulla società*, eds Walter Siti and Silvia De Laude (Milan: Mondadori, 1999), 1171–4; originally published in *Tempo* no. 2, 11 January 1969. In this context, Pasolini attributed his problems with making the film to his own political/religious persecution at the hands of his enemies. On the other, in published interviews with Jon Halliday, conducted between 1968 and 1971, and with Jean Duflot, conducted between 1969 and 1975, Pasolini speaks of the project as if it might still be possible. The Halliday interviews are anthologized as 'Pasolini su Pasolini: Conversazioni con Jon Halliday (1968–1971)' in *Saggi sulla politica e sulla società*, 1283–1399; the Duflot interviews are collected in the same volume as 'Il Sogno del centauro: Incontri con Jean Duflot (1969–1975)', 1401–1550. Moreover, in an interview

saint-prophet-founder Paul – had long captivated and haunted Pasolini, not merely as a historical subject but as both an analogical lens through which to read his contemporary political context and a semi-autobiographical figure for his own artistic and personal experience of alienation and persecution.

Although Pasolini generated the initial treatment for the project in 1966 ('these few little pages' to which he makes reference in the May 1966 letter to Don Cordero), the majority of the script for the film was written over a very short period in May and June of 1968, and it was this draft that accompanied the letter to Don Cordero dated 9 June 1968. Pasolini returned to the work and edited it further in 1974, in anticipation of its publication. That version was published by Einaudi in 1977, and it is the Einaudi edition that is translated here.[7]

I have approached this translation both as a practical exercise in rendering Pasolini's Italian text into standard English but also as an occasion to consider the theoretical importance of Pasolini's work as itself a form of cultural translation – hence, the title of this introduction: 'Translating Pasolini Translating Paul'. Pasolini's *Saint Paul* is a critical precursor – and, in some dimensions, a striking corrective – to the recent series of philosophical interventions about the figure of Paul emerging from continental philosophy. I hope this translation will allow for Pasolini's complex, transgressive text to become part of a broader discussion of the figure of the philosophers' Paul.[8]

conducted in September 1974 by Gideon Bachmann, Pasolini speaks of the film about Saint Paul as a project that he plans to complete. See the discussion of this interview at the end of this essay, along with bibliographical citations at note 41.

7 Pier Paolo Pasolini, *San Paolo*, (Turin: Einaudi, 1977). A version of the text is also found in Pier Paolo Pasolini, *Per il cinema*, 2 vols, eds Walter Siti and Franco Zabagli (Milan: Mondadori, 2001), vol. 2, 1181–2030.

8 See Lorenzo Chiesa, 'Pasolini, Badiou, Žižek und das Erbe der christlichen Liebe', in *Wieder Religion? Christentum im zeitgenössischen*

PASOLINI AND TRANSLATION

Writing about Pasolini's *Il Vangelo secondo Matteo* [Gospel According to St Matthew] in his essay 'Translation as De-canonization: Matthew's Gospel According to Pasolini', biblical scholar George Aichele illuminates how the process of translation – the carrying across of the biblical text into a filmic medium – disrupts the boundaries of canonicity, interrupts the 'biblical' nature of the Gospel, and foregrounds the instability of authoritative claims about scriptural meanings.[9] This is also the project of Pasolini's *Saint Paul*, where Pasolini engages again in a practice of translation, one that renders the biblical Paul as political critic for the contemporary moment – at the time, the late 1960s and early 1970s.[10] Remarkably, Pasolini does this by transposing the story of the first-century Christian communities into new temporal and geographical keys: the first century becomes the post-WWII twentieth century, and the geography of the Roman

kritischen Denken (Lacan, Žižek, Badiou u.a.), eds M. de Kesel and D. Hoens (Vienna: Turia and Kant, 2006), 107–26; Elizabeth A. Castelli, 'The Philosophers' Paul in the Frame of the Global: Some Reflections', *South Atlantic Quarterly* vol. 109, no. 4 (2010), 653–76; reprinted in, eds Ward Blanton and Hent de Vries, *Paul and the Philosophers* (New York: Fordham University Press, 2013), 143–58.

9 George Aichele, 'Translation as De-canonization: Matthew's Gospel according to Pasolini', *Crosscurrents* 51 (2002), 524–34.

10 Francesca Parmeggiani, 'Pasolini e la parola sacra: Il progetto del *'San Paolo'*, *Italica* vol. 73, no. 2 (Summer 1996), 195–214; Silvestra Mariniello, '*St. Paul*: The Unmade Movie', *Cinémas* vol. 9, nos 2–3 (1999), 57–84; Marco Pistoia, 'Storia di un film mai nato: Il *'San Paolo* di Pier Paolo Pasolini', in *La Bibbia e il cinema: Atti del Convegno Internazionale 'Il Cinema e la Bibbia'*, *Genova, Palazzo San Giorgio, 30 ottobre–1 novembre 1999*, ed. Stefano Socci (Brescia: Morcelliana, 2001), 159–72; Armando Maggi, *The Resurrection of the Body: Pier Paolo Pasolini from Saint Paul to Sade* (Chicago: University of Chicago Press, 2009), 21–106; and see also Ward Blanton, '*Reappearance of Paul, "Sick"*: Foucault's Biopolitics and the Political Significance of Pasolini's Apostle', *Journal for Cultural and Religious Theory* vol. 11, no. 1 (Winter 2010), 52–77.

empire and the ancient Mediterranean is remapped onto the postwar American empire and the northern transatlantic world. The specificity of the political moment makes *Saint Paul* more like an artefact than an unfinished work that could, theoretically, be produced at some future moment. That said, one should note that a transatlantic collaboration between La MaMa Experimental Theatre of New York and La MaMa Umbria International has produced a work, *Discovering Pasolini: Appunti per un film mai nato* [Notes for a Film Never Born], based on Pasolini's never-realized Paul project, which was staged in La Pergola in Florence in October 2011 and was scheduled to appear in New York in October 2012.[11] It is possible to consider Pasolini's *Saint Paul* as a broader theoretical reflection upon translation itself – that delicate process of transferring, transmitting, ferrying-across the expressions and commitments and affect of one textual-political world into another. Yet as its theorists will argue, translation is also an act of violence and an act of betrayal. And so, the ambivalent and contradictory meanings of translation – to carry across and to betray – make Pasolini's *Saint Paul* itself a space of ambivalence and contradiction.

Pasolini was himself a prolific translator, in the conventional sense of transforming a literary work from one idiom into another.[12] Theorizing the practice of translation beyond instrumentalism or pragmatism, Pasolini wrote of the capacity within translation for 'regeneration', and of 'the necessity of elective affinities, of mysterious historical correspondences'

11 'La MaMa e i due Paolo *invadono* la Pergola', *Corriere Fiorentino* (27 Ottobre 2011), 23, at http://lamama.org/preview/wp-content/uploads/2011/02/pasolini.pdf. See *Discovering Pasolini: Notes on an unborn movie* at lamama.org.

12 For an overview of Pasolini's translational work, see John P. Welle, '*Pasolini Traduttore*: Translation, Tradition and Rewriting', in *Pasolini Old and New: Surveys and Studies*, ed. Zygmunt G. Barański (Dublin: Four Courts Press, 1999), 91–129.

in the practice of translation such that 'translation is primarily, explicitly or implicitly, a historiographical act'.[13] As critic John Welle observes,

> In fact from the early 1960s until his tragic murder, the majority of Pasolini's 'original' works, including films, poetry, screenplays and verse tragedies, are thinly disguised or explicit 'remakes', 'refractions', 'manipulations', 'adaptations': in short, *rewritings* (in the literal sense of the word) of other texts – most of them classical and canonical, some of them his own. From St Paul to Allen Ginsberg, from Shakespeare to De Sade, Pasolini, primarily in the later stages of his career, rewrote in a highly personal vein a vast array of authors and texts. He also injected elements from various literary traditions into the cinema.[14]

Building on the recognition that translation can be a creative and interpretive attitude as much as a technical practice, a metaphor for culture-making and innovation, I want to suggest that Pasolini's *Saint Paul* is an instance of translation that is, for him, simultaneously an autobiographical and self-fashioning act, an adaptation and remediation of his source material, and a cultural intervention that is simultaneously theological/religious and political.

TRANSLATION AS AUTOBIOGRAPHY AND SELF-FASHIONING

It is not generally defensible (or productive or interesting) to pay much attention to the biographies of writers and artists when analysing and interpreting their work, and yet with Pasolini, one feels called to make an exception to this ordinarily salutary caution.

13 Pier Paolo Pasolini, 'Arte e divulgazione', *Il punto* (8 December 1956), 21, quoted in Welle, '*Pasolini Traduttore*', 112–13 [translation adapted]. See also Pier Paolo Pasolini, *Saggi sulla letteratura e sull'arte*, 2 vols, eds Walter Siti and Silvia De Laude (Milano: Mondadori, 1999), vol. 1, 659–61.

14 Welle, '*Pasolini Traduttore*', 121.

Pasolini's poetry, fiction, essays, and films were, after all, only part of his creative project; the self that he crafted over the course of his fifty-four years was also part of that lifelong endeavour to intervene in the culture of his moment.[15] Enigmatic, contradictory, Pasolini was the son of a father who embraced fascism and a mother who rejected it; the brother of Guido Pasolini, a resistance fighter who was killed in the Porzûs Massacre and whom Pier Paolo mourned as a martyr. Pier Paolo was a sometime communist, an anticlerical Catholic, an unapologetic homosexual whose tastes ran to passing encounters with young urban hustlers (*i ragazzi di vita* – boys in the life). He was educated in the Latin and Greek classics and, in a singularly Pasolinian gesture, at one point had his cousin, Nico Naldini, sell his painstakingly accumulated collection of Teubner editions of the classics, along with the Laterza editions of the Italian literary canon, in order to obtain money to support his sexual habits once he moved to Rome.[16] He was a powerful advocate for local dialects, which he believed were a bulwark against the deadening massification of society. He was taken to court dozens of times, accused of blasphemy, pornography, insulting to the national religion, and corrupting minors. He was a poet, a critic, a filmmaker, and a partisan for radical freedom (for men, at least – his stance toward women's sexual freedom was, to say the least, at times perversely reactionary).[17] He was the friend of the most

15 There have been numerous published biographies of Pasolini. Among them, I have depended primarily on Enzo Siciliano, *Pasolini: A Biography*, trans. John Shepley (New York: Random House, 1982); Nico Naldini, *Pasolini, una vita* (Torino: Einaudi, 1989); and Barth David Schwartz, *Pasolini Requiem* (New York: Pantheon, 1992).

16 Siciliano, *Pasolini*, 154.

17 See, for example, his debate with Alberto Moravia over the legalization of abortion in Italy: Pier Paolo Pasolini, '30 gennaio 1975. *Sacer*', in *Scritti corsari* (Milano: Garzanti, 1975), 132–7, reprinted in *Saggi sulla politica e sulla società*, 380–4 (originally published in *Corriere della Sera*); and '25 gennaio 1975. *Thalassa*', in *Scritti corsari*, 138–43, reprinted in *Saggi sulla politica e*

Introduction XXIII

important Italian writers of his day – Carlo Emilio Gadda, Cesare Pavese, Alberto Moravia, Elsa Morante, Italo Calvino and Attilio Bertolucci, among others. Anna Magnani and Maria Callas both emerged from seclusion to perform in his films – Anna Magnani in *Mamma Roma* and Maria Callas in *Medea*. In an unpublished interview, the famed Italian film director Bernardo Bertolucci called Pasolini a saint.[18] Deeply Catholic themes of persecution and martyrdom pulsated throughout his life, especially in his judicial entanglements in which he was repeatedly charged with religious and erotic deviancies.[19] In the end, his life culminated in a broad and almost theatrical materialization of these themes, his notorious murder in 1975 quickly transmogrifying into a sensational, erotically charged martyrdom story in which Pasolini's death was attributed to his experiential collision with a manifestation of his own literary invention, a murderous hustler.[20]

sulla società, 385–9 (originally published in *Paese Sera*).

18 Robert Gerber, interview with Bernardo Bertolucci; personal communication.

19 *Pasolini: cronaca giudiziaria, persecuzione, morte*, ed. Laura Betti (Milan: Garzanti, 1977).

20 This is one interpretation of Pasolini's death put forward by one biographer who also highlights the uncertainties surrounding the facts of the murder; Siciliano, *Pasolini*, 18–19. It should be noted that Pasolini's murder remains a mystery, despite the confession extracted from Giuseppe Pelosi, or, as he was known on the streets, Pino la Rana (Joey the Frog), a young hustler who was arrested in possession of Pasolini's car on the night of the murder. In May 2005, Pelosi recanted his confession, and soon afterwards, a new investigation into the murder was briefly undertaken, but ultimately shelved in October of the same year. See Doug Ireland, 'Restoring Pasolini', *LA Weekly*, 4 August 2005. In support of the theory that Pasolini's murder was politically motivated, see (for example) Maria-Antonietta Macciocchi, 'Pasolini: Murder of a Dissident', *October* 13 (Summer 1980), 11–21. Also see Alberto Moravia, 'Il dovere di morire', the preface to *Pasolini: cronaca giudizia, persecuzione, morte*, 3. In this preface, Moravia observes that, while the murder itself was carried out by a few individuals, 'the instigators of the crime are legion, in fact, all of Italian society'. Numerous other critics

Scholars who have explored the autobiographical dimensions of Pasolini's writings have noted his attachment to the dominant Mediterranean myth (that of Christ) and, more significantly for this essay, to the historical figure of the apostle Paul.[21] Individual characters in some of Pasolini's earlier writings bear the name of Paul – Don Paolo, for example, a homosexual priest who appears in an early play from 1947, *Il Cappellano* (The Chaplain), – while some of his early literary experiments undertake a mode of poetic exegesis of Paul's writings, such as the 'Paolo e Baruch' section of his poetry collection *L'usignolo della Chiesa Cattolica* (The

and interpreters read Pasolini's death as an almost literary/artistic event, an unwitting performance of martyrdom. See, for example, Roberto Carnero, *Morire per le idee: Vita letteraria di Pier Paolo Pasolini con un'appendice sul caso giudiziario* (Milano: Bompiani, 2010). See also Giuseppe Zigaina, *Pasolini e la morte: Un giallo puramente intellettuale* (Venice: Marsilio Editori, 2005). Finally, one must take note of the beautiful cinematic homage to Pasolini in a scene from *Caro Diario* (*Dear Diary*), dir. Nanni Moretti (1993), in which Moretti journeys to the place of Pasolini's murder, a pilgrimage on a motor scooter documented in the style of a classic Pasolinian long take. On the meaning of the long take, see Pier Paolo Pasolini, 'Observations on the Long Take', trans. Norman MacAfee and Craig Owens, *October* 13 (Summer 1980), 3–6.

21 Tomaso Subini, 'La caduta impossibile: San Paolo secondo Pasolini', in *Il Dilettoso Monte: Raccolta di saggi di filologia e tradizione classica*, ed. Massimo Gioseffi (Milan: Edizioni Universitarie di Lettere Economia Diritto, 2004), 221–66; Ilario Quirino, *Pasolini sulla strada di Tarso* (Lungro, Cosenza: Costantino Marco Editore, 1999). Naomi Greene, *Pier Paolo Pasolini: Cinema as Heresy* (Princeton: Princeton University Press, 1998), 178, writes: 'The acute sense of persecution he experienced at this time was intensified by his inability to realize a cherished project for a film about St. Paul – a film that would transpose the saint's drama into the contemporary world. The published scenario leaves no doubt that Pasolini viewed the father of the Church in a deeply autobiographical light: a lonely prophet … Like Pasolini, this unhappy saint is misunderstood and mocked by the progressive intellectuals who should best have understood him …' See also Robert S. C. Gordon, *Pasolini: Forms of Subjectivity* (Oxford: Clarendon Press, 1996), 81, 201–2.

Introduction

Nightingale of the Catholic Church), from 1948–49.[22] Meanwhile, in his correspondence and journalism, Pasolini repeatedly used the figure of Paul falling from his horse (on the road to Damascus) to describe his own psychological/theological state.[23] Moreover, from the early 1960s, the figure of Paul – and the doubledness of that figure, as it will emerge full-blown in Pasolini's *Saint Paul* – also plays a role in Pasolini's articulation of his own politics, notably in a major essay, 'Marxismo e Cristianesimo'.[24] Finally,

22 See Subini, 'La caduta impossibile', 223–4, especially concerning the scandalous quality of the priest in *Il Cappellano*, and the complicated publication history of the play. Italo Calvino, for example, wrote to Pasolini in 1961, when a version of the play was circulating under the title *Storia interiore* (Internal Story): 'The manuscript of *Storia interiore* fell into my hands and I read it. But what has happened to you? Immediately withdraw all the copies of the manuscript that are in circulation and make sure that anyone who has read it does not speak of it. As I am committed to do.' In *Lettere, 1955–1975*, 489. Pier Paolo Pasolini, *L'Usignolo della Chiesa Cattolica* (Torino: Einaudi, 1976).

23 Subini, 'La caduta impossibile', 228. For example, Pier Paolo Pasolini, 'Una discussione del '64', in *Saggi sulla politica e sulla società*, 748–85, at 749–50, in response to a question about the politico-religious implications of his film *Il Vangelo secondo Matteo*: '... I respond that a fall from the horse ... on the road to Damascus didn't occur for the simple reason that I was dismounted from the horse and for a good long time already, dragged, still bound to the stirrup, striking my head on the dust, the stones, and the mud of the road of Damascus! Thus nothing happened: I didn't fall because I had already fallen and been dragged by this horse, let us say, of rationality, of the life of the world.' See also Pier Paolo Pasolini, 'A Don Giovanni Rossi – Assisi, Roma, 27 dicembre 1964', in *Lettere, 1955–1975*, 576–7: 'I am "blocked", dear Don Giovanni, in a fashion that only the Grace [of God] could dissolve. My will and that of others are impotent ... Perhaps this is why I am always fallen from the horse: I've never been boldly in the saddle (like many powerful people in life, or many miserable sinners): I have always been fallen, and one of my feet is caught in the stirrup ... I can neither get back up on the horse of the Jews and the Gentiles, nor fall for good onto the ground of God.'

24 Pier Paolo Pasolini, 'Marxismo e Cristianesimo', in *Saggi sulla politica e sulla società*, 786–824.

numerous commentators have connected Pasolini's grief and mourning for his martyred brother, Guido, with the portrait of the first Christian martyr, Stephen, in Pasolini's *Saint Paul*.[25]

These numerous autobiographical resonances, which echo most forcefully through the script for the Paul film, also intersect with the religio-political and historiographical elements of Pasolini's project of cultural translation and cultural critique.

TRANSLATION AS ADAPTATION, REMEDIATION, AND THE TRACING OF 'MYSTERIOUS HISTORICAL CORRESPONDENCES'

Pasolini's project for a film about Paul emerged relatively late in his filmmaking career, and can be plotted along a trajectory of classical adaptation, read alongside not only *Il Vangelo secondo Matteo*, but also *Medea*, *Appunti per un'Orestiade Africana*, *Edipo re*, *La trilogia della vita* (*Il Decameron*, *I racconti di Canterbury*, *Il fiore delle Mille e una notte*), and even *Salò, o le centoventi giornate di Sodoma*. In each case, Pasolini experiments with a classical or canonical model – the Gospel of Matthew, the myths of Medea and Oedipus, the Oresteia (which he had originally translated in 1960 for Vittorio Gassman for a production at the Teatro Popolare), Boccaccio's *Decameron*, Chaucer's *Canterbury Tales*, *The Arabian Nights*, and even the Marquis de Sade. In each case, Pasolini worked in a deeply analogical fashion, resituating these classics and the very notion of the canonical within some sort of (inevitably radical) commentary on his own social, cultural, and political worlds.[26]

25 For example, Subini, 'La caduta impossibile', 264–6. On Guido's death and Pier Paolo's eulogies for his brother, see Siciliano, *Pasolini*, 90–3.

26 Pasolini's analogical method has been the subject of considerable scholarly discussion. See, for example, Alessia Ricciardi, 'Heretical Specters', in *The Ends of Mourning: Psychoanalysis, Literature, Film* (Stanford, CA: Stanford University Press, 2003), 123–65, and Noa Steimatsky, 'Pasolini

Introduction

Pasolini would likely not have wanted his *Saint Paul* to be read simply as a cinematic adaptation of a literary precursor – and, indeed, his New Testament source material for the script is rendered more fragmentary in the process: parts of the Acts of the Apostles, alongside cannibalized and reformulated quotations from the Pauline, deutero-Pauline, and Pastoral Epistles. Despite Pasolini's insistence in the early pages of *Saint Paul* that he plans to be 'utterly faithful' to the original text – more on this in a moment – his project, I would argue, is an adaptation in precisely the sense that adaptation has been theorized widely, as the remediation of source material into a new cultural form. In other words, Pasolini's *Saint Paul* is an instance of remix.[27]

But one can also situate *San Paolo* along a different trajectory, one concerned less with the high literary legacy of the Western canon and more concerned with articulating an explicitly religious vision profoundly grounded simultaneously in Catholic symbolism and narrative, on the one hand, and radical political conviction and cultural critique, on the other. Pasolini railed

on *Terra Sancta*: Towards a Theology of Film', in *Rites of Realism: Essays on Corporeal Cinema*, ed. Ivone Margulies (Durham, NC: Duke University Press, 2003), 245–69.

27 The critical literature on adaptation is vast. See Linda Hutcheon, *A Theory of Adaptation* (New York: Routledge, 2006). On Pasolini, see Millicent Marcus, *Filmmaking by the Book: Italian Cinema and Literary Adaptation* (Baltimore: Johns Hopkins University Press, 1993); on the question of fidelity in the film adaptation of religious texts, see Thomas M. Leitch, *Film Adaptation and Its Discontents: From* Gone with the Wind *to* The Passion of the Christ (Baltimore: Johns Hopkins University Press, 2007). For an especially theoretically sophisticated approach to politically inflected cinematic adaptations, see eds Susan G. Figge and Jenifer K. Ward, *Reworking the German Past: Adaptations in Film, the Arts, and Popular Culture* (Rochester: Camden House, 2010). On remix theory (as an analogy for Pasolini's own analogical methodology), see Eduardo Navas, *Remix Theory: The Aesthetics of Sampling* (Springer Vienna Architecture, 2012) and the related website, remixtheory.net.

against what he called, in a polemic addressed to young people in 1968, 'bourgeois entropy',[28] which he rather presciently predicted would overwhelm modern society and render the peasant and the worker invisible. Such entropy would, in his view, make unsentimental expressions of authenticity increasingly difficult, not to say completely impossible – just as the domination of reductive forms of language, which he saw in 'the horrendous language of television news, advertising, official statements', and consumerism, and which he called 'a genuine anthropological cataclysm', impoverish existence and threaten 'to eclipse "the grace of obscure centuries ... the scandalous revolutionary force of the past." '[29] The last phrase comes from the closing lines of Pasolini's documentary *Le mura di Sana'a* (The Walls of Sana'a), which he made as a plea to UNESCO to preserve the cultural legacy he encountered in Yemen while filming *The Arabian Nights*:

> In the name of simple men whom poverty has kept pure.
> In the name of the grace of obscure centuries.
> In the name of the scandalous revolutionary force of the past.[30]

28 Pier Paolo Pasolini, 'The PCI to the Young!! (Notes in Verse for a Prose Poem Followed by an "Apology")', *Nuovi Argomenti* no. 10 (April–June 1968), reprinted in *Heretical Empiricism*, ed. Louise K. Barnett, trans. Ben Lawton and Louise K. Barnett (Bloomington: Indiana University Press, 1988), 156.

29 Quoted in George Scialabba, 'Lust for Life', *The Nation*, 22 January 2004. On consumerism as 'a genuine anthropological cataclysm', see Pier Paolo Pasolini, '30 gennaio 1975, *Sacer*', in *Scritti corsari*, 132–7, quotation at 134; also in *Saggi sulla politica e sulla società*, 380–4, quotation at 382. On 'horrendous language', see Paolo Volponi, 'Pasolini maestro e amico', in *Perché Pasolini: Ideologia e stile di un intellettuale militante*, eds Gualtiero De Santi, Maria Lenti, and Roberto Rossini (Firenze: Guaraldi, 1978), 15–28, quotation at 26.

30 Pier Paolo Pasolini, *Le Mura di Sana'a: Documentario in forma di appello all'UNESCO*, in *Per il cinema*, 2 vols, eds Walter Siti and Franco Zabagli (Milan: Mondadori, 2001), vol. 2, 2105–10, quotation at 2110:

Introduction

This impulse toward a kind of revolutionary and profoundly unsentimental authenticity (as a counterweight to bourgeois conformism) generated a kind of nostalgia for history but also inspired Pasolini to translate his literary strategy of *affabulazione* (fablemaking, mythmaking) into a cinematic strategy and to address the question of temporality through recourse to myth. This strategy makes itself most plain in his theologically inflected films, all of which in different registers stage a confrontation between two incommensurate systems of value. In each case, one encounters a vigorous defence of the religious and the sublime – what Pasolini called his 'nostalgia for the sacred',[31] set against the dominant forms of power and cultural value.

One sees this confrontation play out mythically early on in Pasolini's cinematic work, notably in the short film *La Ricotta* (1963), where Pasolini first sought to use religious/mythic imagery in the medium of film to ground a political critique. Despite its evident 'nostalgia for the sacred', the film was banned for a time and resulted in Pasolini's prosecution for 'insult to the national religion'. He was found guilty and sentenced to four months, but this was overturned on appeal. The prosecutor, Giuseppe Di Gennaro, closed his summation in the case with these striking words: 'Let

In nome degli uomini semplici che la povertà ha mantenuto puri.
In nome della grazia dei secoli oscuri.
In nome della scandalosa forza rivoluzionaria del passato.

Discussed in Serenella Iovino, 'The Ashes of Italy: Pier Paolo Pasolini's Ethics of Place', in *Culture + the State: Landscape and Ecology*, Papers from the Conference held 2–5 May 2003 at the University of Alberta, Edmonton, eds Gabrielle E. M. Zezulka-Mailloux and James Gifford (Edmonton: CRC Humanities Studio, 2003), 70–91, quoted at 84–5. The film, shot on 18 October 1970, was produced in 1974.

31 Pier Paolo Pasolini, 'L'apocalisse secondo Pasolini', in *Il Sogno del centauro*, ed. Jean Duflot (Rome: Riuniti, 1983), 49–56, quotation at 53; reprinted in *Saggi sulla politica e sulla società*, 1442–50, quotation at 1447.

Catholics beware of carrying the Trojan horse of Pasolini into the city of God.'[32]

La Ricotta is a film is about the making of a film of the Passion of Christ, focusing on the character of a subproletarian actor named Stracci (Rags), who portrays the good thief, one of the two thieves crucified alongside Jesus. At the centre of the film is Stracci's desperate effort to obtain food – both for his family, portrayed by a peasant woman and her children, and for himself. When the lunch he has acquired through travesty and subterfuge is eaten by the spoiled pet dog of the female star of the film, Stracci sells the dog for 1,000 lire to a journalist who has been on the set to interview the director. With the money, Stracci buys a large portion of ricotta cheese, on which he gorges himself while the film crew looks on and mocks him. Eventually suspended on a cross for the filming of the crucifixion in the film-within-a-film, Stracci dies from his bout of overeating.

The film juxtaposes incommensurate elements and filmic styles to produce unsettling and sometimes absurd effects: the film-about-making-a-film is shot in black and white, while the passion film – itself a tableau vivant based upon two famous Renaissance paintings of the deposition from the cross, one by Giovanni Battista di Jacopo (Rosso Fiorentino) from 1521 and the other by Pontormo from 1528 – appears in vibrant, even garish colour, as does the lavishly laden table of food that remains out of reach of the starving actor. Stracci's hunger and the desperate lengths to which he will go to relieve it are portrayed in comical and absurdist fashion, from the ridiculous disguise he dons in order to claim a second lunch on the set after he has given his own food to his wife and children, to the sped-up style, borrowed from silent film, by which Stracci's struggle is narrated in visual shorthand. Stracci, a

32 Siciliano, *Pasolini*, 254; see also Betti, *Pasolini: cronaca giudiziaria, persecuzione, morte*, 162: 'stiano attenti i cattolici a non portare nella città di Dio il cavallo di Troia'.

Introduction XXXI

subproletarian portraying the unnamed good thief, becomes the true martyr of the Passion story, while Christ appears primarily in the visual restaging of the Renaissance masterpiece.

Meanwhile, as the film juxtaposes the ancient myth with the modern cultural-political setting, the director, played by Orson Welles, quotes a Pasolini poem to the journalist who interviews him, expressing the nostalgia for a different temporality:

> I am a force of the Past.
> Tradition alone is my love.
> I come from ruins, from the Churches,
> from the altarpieces, from villages
> forgotten of the Apennines and the foothills of the Alps
> where my brothers lived.
> I wander the Tuscolana Way like a madman,
> through the Appian Way like a dog without a master.
> Or I look at the twilights, the mornings
> over Rome, over Ciociaria, over the world,
> like the first acts of post-history,
> which I witness by the privilege of being born,
> from the outermost border of some buried
> era. Monstrous is the one born
> from the viscera of a dead woman.
> And I, an adult fetus, roam around
> more modern than all the moderns
> to search for brothers who are no more.[33]

The poem expresses nostalgia, but also a kind of flexible temporality that characterizes many of Pasolini's efforts to bring the past

33 Pier Paolo Pasolini, *La ricotta*, in *Per il cinema*, vol. 1: 326–51, quotation at 337. The poem is Pasolini's, a portion of 'Poesie mundane', in *Poesia in forma di rosa* in *Tutte le poesie*, ed. Walter Siti (Milan: Mondadori, 2003), vol. 1, 1093–1101, quotation at 1099. The stanza of which this poem is a part bears the date 10 June 1962.

into creative and critical relationship to his present. This vision of a flexible temporality will become a part of the very structure of *Saint Paul*.

The politics of *La Ricotta*, which place 'religion' on the side of the oppressed, would reappear frequently in Pasolini's theorization of the relationship between religion and politics. Throughout, Pasolini remained faithful to a notion of religion that was consonant with his radical politics, characterized by a deep solidarity with ordinary people. As he put it in a series of reflections and observations he offered to an English journalist, which he called 'almost a spiritual-intellectual testament', and which appeared in print only after his death, 'To conclude I would like to say however that the "opposite" of religion is not communism (which, despite having taken the secular and positivist spirit from the bourgeois tradition, in the end is very religious); but the "opposite" of religion is capitalism (ruthless, cruel, cynical, purely materialistic, the cause of human beings' exploitation of human beings, cradle of the worship of power, horrendous den of racism).'[34] 'Religion' retains for Pasolini the revolutionary power of human solidarity, a bulwark against the materialist noise of bourgeois culture. It is this 'religion' that he sees embodied in the persecuted and physically suffering part of his character, Saint Paul, in almost ontological contrast to the institutionalizing and officious part of the character.

Affabulazione becomes a tool for Pasolini's other theologically inflected films, among them *Teorema*, a film about God appearing as a mysterious stranger, a beautiful and inscrutable young man who confronts and transforms each member of a bourgeois family through erotic seduction and sexual encounter. When he then disappears, each family member experiences some kind of transformative crisis. This was a film about God's encounter with

[34] Pier Paolo Pasolini, '[Quasi un testamento]', in *Saggi sulla politica e sulla società*, 853–71, quotation at 859. Original publication in *Gente*, 17 November 1975.

Introduction

the world and humanity as perhaps only Pasolini could tell it – the sacred manifesting itself not only incarnationally but also carnally, disrupting bourgeois conformity and ushering in something like a crisis of the sublime.

The film premiered at the 29th Venice Film Festival in September 1968 and received an award there from the Office Catholique Internationale du Cinéma, the organization which had also rewarded *Il Vangelo secondo Matteo*. Yet in a polemic published in the *Osservatore Romano*, the Vatican protested the bestowal of this award, calling the figure of *Teorema* a 'disturbing metaphor' undermined 'at the roots by Freudian and Marxist consciousness'. 'The mysterious guest', the text went on, 'is not the image that liberates and frees man from his existential torments, from his limitations and impurities, but is almost a demon.'[35] It was in part as a consequence of the scandal surrounding *Teorema*, which included the public prosecutor of Rome calling for the confiscation of the film on grounds of obscenity,[36] that Pasolini could not engage support for his Paul project.

Pasolini's *Saint Paul*, however, offers a kind of culmination of the autobiographical, artistic, political, and religious dimensions of his method of adaptation and affabulation. In *Saint Paul*, he proposed to create a portrait of Paul with 'absolute fidelity' to the biblical text, refusing to 'manipulate or alter' the words of the apostle. This curious commitment to 'absolute fidelity' to *the word* of the text – even as he is thoroughly at ease with temporal and topographical transpositions – attunes us to Pasolini's striking essentialism and his desire to preserve a pure and universal theological message (one aligned with his political commitments) in stark contrast to the corruptions of the institutional Church. Moreover, this fidelity stands in striking contrast to Pasolini's

35 Siciliano, *Pasolini*, 318; quoting *Osservatore Romano* on 13 September 1968.

36 Siciliano, *Pasolini*, 317.

adaptations, appropriations, and remixes of other important canonical works, from the Greek classics onward.[37]

In any case, Pasolini's confessed commitment to textual fidelity runs rather violently up against his political project: how can he be faithful to the biblical narrative and epistolary archive, when the narrative and letters themselves seem to serve the institutionalizing project against which he has positioned himself? Pasolini's response is idiosyncratic and heresiological at once: having recognized the institutionalizing impulse driving the narrative of the Acts of the Apostles, Pasolini inserts a new and scandalous detail into the story by portraying Luke, the purported author of Acts, as a false disciple of Christ and a true minion of the Devil. Embodying paradox as only Pasolini could, the self-described heretic here becomes the unmasker of heresy.

But if Pasolini sought, however idiosyncratically, to act faithfully in relation to his source material, he was also concerned with other broad themes – troubling over temporality, as he had in other projects. In *Saint Paul*, he addresses himself to two different sets of tensions: his conviction that temporal difference is, at its root,

37 Welle, *Pasolini Traduttore*, 111:

As is well known, throughout his film career Pasolini rewrote ancient, medieval and modern canonical texts, including *Oedipus Rex*, St. Matthew's Gospel, the *Divine Comedy*, the *Decameron*, the *Canterbury Tales* and numerous others, in a highly personal manner. Running the gamut from the 'faithful' adaptation (*Il Vangelo secondo Matteo*, 1964) and clearly autobiographical writing (*Edipo re*, 1967) to explicitly transgressive interpretation (*Il Decameron*, 1971 and *I racconti di Canterbury*, 1972), Pasolini assumed the identities of some of the most prestigious literary *auctores* of Western civilization. For example, in his film adaptations Pasolini's cameo appearances as Giotto's disciple in the *Decameron*, as Chaucer in *I racconti di Canterbury*, and as a character in *Edipo re* provide visual proof of how Pasolini sought to assume an identity different from his own.

See also *Il mito greco nell'opera di Pasolini*, ed. Elena Fabbro (Udine: Forum Editrice Universitaria Udinese, 2004).

Introduction

illusory – that there is no distance between then and now – and his consistent worrying over the separation between the historical and the religious, the real and the ideal.

One encounters his argument for the tactile and experiential presence of the past in a poem he wrote in 1969 while shooting the film *Medea* in Turkey, the year after the drafting of the Paul script. The poem is called 'Tarsus, from a Distance':

Tarsus, from a distance
A streak of lights appeared like a phosphorescent worm
(beyond the last gorges of the Taurus mountains)
There was the sea there below
the gorges opened up
the plain was mysteriously warm
The signpost is blue like in Germany,
indicating 'Tarsus' with great unselfconsciousness.
Of course, if a thing changes
it still remains what it was first.
Our heart leapt there in an eager breast
Of course, for us, all this time has been a parenthesis,
closed by our arrival. These eternal
two millennia were abolished. The point at which Paul
was there and the point at which We arrived were contiguous
Of course, the egg-shaped form of time connects everything.
With the eternal untimeliness I do not conceal my emotion,
I am agitated in my seat, I look ostentatiously outside
(not seeing anything naturally, because it is night, and vanished
already is the ancient tremulous thread of light over the sea), in short
I have re-found the place, I re-see the actions, I re-hear the
words (I mutter the Greek of the patrimonial sentences;
the *agape* of custom and the unfailing *pneuma*)
I smile on Gnosis like on an old familiar thing.
The reality is that I would like to smash the egg
and all the Easter returns; to abandon
once and for all the curved line, with its Pauls
and all the rest ... Instead I am incorrigible.

Before our eyes a gas station appears
and our heart, which loves origins, ignores it.[38]

38 Pier Paolo Pasolini, 'Tarso, da lontano', in *Bestemmia: Tutte le poesie*, 2 vols, eds Graziella Chiarcossi and Walter Siti (Milan: Garzanti, 1993), vol. 2, 1888–9:

Tarso, da lontano
È comparsa una striscia di luci come un verme fosforescente
(oltre le ultime gole del Tauro)
c'era il mare laggiù
le gole si schiusero
la pianura era misteriosamente tiepida
Il cartello segnaletico è blu come in Germania,
indica «Tarsus» con grande naturalezza.
Eh già, se una cosa muta
rimane anche ciò che essa era prima.
Il Nostro cuore ci balzò in petto premuroso
Eh già, per Noi tutto questo tempo è stata una parentesi,
chiusa dal Nostro arrivo. Furono aboliti
questi eterni due millenni. Il punto in cui Paolo
era lì e il punto in cui Noi arrivammo furono contigui
Eh già, la forma d'uovo del tempo ci congiunge tutti
Con l'eterna inopportunità non nascondo la mia emozione,
mi agito sul sedile, guardo ostentatamente fuori
(non vedendo naturalmente nulla, perché è notte, ed è scomparsa
anche l'antica fila tremolante di luci sul mare), insomma
ho Ri-trovato il luogo, Re-vedo le azioni, Ri-ascolto le parole
(borbotto il greco delle frasi patrimoniali;
l'«agape» di prammatica e l'immancabile «pneuma»)
sorrido della Gnosi come di una vecchia cosa famigliare.
La realtà è che vorrei sfracellare l'uovo
e tutti i ritorni pasquali; abbandonare
una volta per sempre la linea curva, coi suoi Paoli
e tutto il resto ... Invece sono incorreggibile.
Davanti ai Nostri occhi appare un benzinaio
e il Nostro cuore, che ama le Origini, lo ignora.

Discussed in Silvestra Mariniello, 'Temporality and the Culture of Intervention', *Boundary 2* vol. 22, no. 3 (Autumn 1995), 111–39, discussed at 136–7.

Introduction

Pasolini frames his experience of glimpsing Tarsus, Paul's ancestral home, as an occasion of collapsed time: 'Of course, for us, all this time has been a parenthesis,/closed by our arrival. These eternal/two millennia were abolished. The point at which Paul/ was there and the point at which We arrived were contiguous/Of course, the egg-shaped form of time connects everything.' And just so, the modern experience of travel – on roads marked by blue road signs like they have in Germany, roads punctuated by gas stations – allows Pasolini a different kind of journey, a journey into a mythical space of temporal slippage so that his moment and Paul's moment touch.

But if Pasolini fantasizes a moment where geographical proximity can produce a temporal alignment between himself and Paul, he nevertheless maintains a starkly critical relationship to the figure of Paul himself, whom he views as a radically split subject, a view he made explicit in his June 1968 letter to Don Emilio Cordero. Paul is, in Pasolini's estimation, a radically doubled figure – 'religious' or 'mystical' on the one hand, 'institutional' and 'corrupt' on the other. This theme emerges repeatedly in Pasolini's writings.

For example, in his 1971 poems collected under the title *Trasumanar e organizzar* (Transcendence and Organization), one encounters these lines:

Potrei parlare di UNO che è stato rapito al Terzo Cielo: invece parlo di un uomo debole: fondatore di Chiese.

I could speak of ONE who was snatched up to the Third Heaven, instead I speak of a weak man: a founder of Churches.[39]

39 Pier Paolo Pasolini, *Trasumanar e organizzar* (Milan: Garzanti, 1971), 22. Also cited, with slightly different translation, in Robert S. C. Gordon, *Pasolini: Forms of Subjectivity* (Oxford: Clarendon Press, 1996), 159.

These are the last two lines of a poem entitled 'L'enigma di Pio XII' (The Enigma of Pius XII), in which the pope who was responsible for the Church's inaction during the Holocaust attempts to justify himself. As Pasolini ventriloquizes the pope, he inscribes the opposition between mysticism and clericalism which he repeatedly saw embodied in the double figure of Paul – concerning whom he wrote to Don Emilio Cordero about the 'theological film' he hoped to make, the one that would challenge the spectator to choose between 'the saint' and 'the priest'.

Meanwhile, in the first draft of the screenplay for *Saint Paul*, this stark diagnosis of the radically dual nature of Paul also appears, in words that do not find their way into the published version of the script: 'Paul too was full of duality! There were two Pauls! There were two natures in Paul! Paul had two faces. And you will see them: a hard and sure face, a weak and lost face; a sane face and a mad face ... a reactionary face and a revolutionary face. Thus he reproduced the duality of God, and he provoked scandal. Rather, he *provokes* scandal.'[40]

And some years later, in an interview with film critic Gideon Bachmann in September 1974, Pasolini explains the politics of his *Saint Paul* and his radical critique of the Catholic Church. He claims to have rethought the film, 'in the sense that I have rendered it more radical and violently anticlerical'. He goes on:

40 Gordon, *Pasolini: Forms of Subjectivity*, 202 (Gordon's translation), quoting from unpublished manuscript: Pier Paolo Pasolini, 'San Paolo', typescript of various drafts, May–June 1968, Rome: Biblioteca Nazionale, Dono Eredi Pasolini 1977/80, V.E. 1563/1[1-11]–3, p. 14:

Anche Paolo fu pieno di doppiezza! Ci furono due Paoli! Ci furono due nature in Paolo! Paolo ebbe due volte. E li vedrete: un volto duro e sicuro, un volto debole e smarrito; un volto sano, e un volto matto; [...] un volto di reazionario e un volto di rivoluzionario. Così egli riprodusse la doppiezza di Dio, e diede scandalo. Anzi, dà scandalo.

Introduction

now the sense of the film is a most violent thing, such as has never been made, against the Church and against the Vatican, because I make a double Saint Paul, I mean schizophrenic, completely dissociated in two: one is the saint (obviously Saint Paul had a mystical experience – that's clear from the letter – that was also authentic), the other instead is the priest, ex-Pharisee, who recuperates his prior cultural situations and who will be the founder of the Church. For this I condemn him: insofar as he is a mystic, that's all right, it is a mystical experience like others, respectable, and I don't judge it, but rather I violently condemn him as the founder of the Church, with all the negative elements of the Church already present: the sexphobia, the anti-feminism, the organization, the collars, the triumphalism, the moralism. In sum, all the things that have created the evil of the Church are all already in him.

He continues to make the distinction that will haunt his portrait of Paul in the *Saint Paul* script, between 'Church' and 'religion' – between the institutional formation that has provided a cynical alibi for the powerful, on the one hand, and that critical force that has the potential to stand up to power:

So, what makes me angry is this: now that the bourgeois powerful excludes it [the Church] with such cynicism after being dependent upon it for a century (contradictorily, because the bourgeoisie is not religious, but it was useful to it, and so cynically depended on the Vatican and justified its crimes, its imperialisms, its genocides, its exploitations with the alibi of the Vatican); now that the bourgeois power, after it has exploited it [the Church] for so many years, it doesn't know what to do with it and has thrown it overboard, the Church ought to change politics radically and pass over decisively to the opposition. At this point, having become a true religion, it ought to be violently opposed to power, and instead it doesn't do it: now if the fact that for so many centuries it has served power, was power itself, made me angry, what makes me even more angry now is that it is silent in a moment in

which it ought to speak, ought to place itself at the head of the opposition, because the opposition to the new power can only be an opposition of religious character.

And he closes the discussion with a paradox, responding to his interlocutor's question as to whether the film is a religious film:

> Yes, in a certain sense yes. It is called *Blasphemy*: and you know very well that in ancient sacred rites, as in all the peasant religions, every blessing amounts to a curse. Thus every blasphemy is a sacred word. Obviously, this, my violence against the Church is profoundly religious, insofar as I accuse Saint Paul of having founded a Church rather than a religion. I do not revive the myth of Saint Paul, I destroy it.[41]

This destruction of the myth of Paul was to have been accomplished through a complex process of adaptation, analogization, and affabulation. Verbal quotations from the New Testament epistles are cobbled together with archival footage of occupied France and staged scenes in bourgeois apartments in Geneva and rundown tenements in 1960s Greenwich Village. The character of Paul is radically split in two – sometimes a mystic who suffers from an unnamed physical malady and from persecution by both the state authorities and the intelligentsia who should have been his allies but who misread his project; sometimes a ruthless organization

41 Gideon Bachmann, 'La Perdita della realtà e il cinema inintegrabile: Conversazione di Pier Paolo Pasolini con Gideon Bachmann: Chia (Viterbo), 13 settembre 1974', in *Pier Paolo Pasolini: Il cinema in forma di poesia*, ed. Luciano De Giusti (Pordenone: Cinemazero, 1979), 152–61, quotation at 156–7. For various versions of this interview (in excerpt or entirety), see also Luigi Martellini, *Ritratto di Pasolini* (Roma: Laterza, 2006), 126–7; Nico Naldini, *Pasolini, Una Vita*, 380–2; and Pier Paolo Pasolini, 'Settembre 1974: Ora la Chiesa dovrebbe mettersi alla testa dell'opposizione', in *Interviste Corsare sulla politica e sulla vita, 1955–1975*, ed. Michele Gulinucci (Rome: Liberal Atlantide Editoriale, 1995), 235–7.

man whose mission is institutionalization, hierarchy-building, and routinization. Meanwhile, the story of Paul concludes in Pasolini's text in a weirdly idiosyncratic fashion, thoroughly unfaithful to the sources to which he had earlier pledged absolute fidelity. For in the end, whoever else Pasolini's Paul is, he is most certainly a martyr, and so the story of this Paul does not – cannot – culminate in a triumphant and bold speech delivered in the centre of the empire, as the Acts of the Apostles would have it. Rather, Pasolini's Paul dies from an assassin's bullet – on a hotel balcony in Greenwich Village sometime in the 1960s. To make the martyrological point explicit, Pasolini wanted to shoot the scene on the balcony of the Lorraine Hotel in Memphis, Tennessee, where Martin Luther King Jnr had been assassinated just weeks before Pasolini completed his work on the full draft of the screenplay for *Saint Paul*.[42] The myth of Paul is destroyed, but another one is created to replace it – a neorealist fabula wherein the saintly and persecuted visionary bleeds out on a hotel balcony and the institutional men manage to proceed with the grand project of consolidating their power.

We will never know quite what Pasolini's *Saint Paul* would have looked like had he had the opportunity to complete the project and make the film. But insofar as his notes and outline for the film give us a glimpse, we see a radical religio-political vision

42 Pasolini felt drawn to the political tumult of the United States in the 1960s, and it was this affinity that made him want to set major parts of *Saint Paul* in New York. As he put it in an interview with the Italian journalist Oriana Fallaci in October 1966, soon after his first visit to New York: 'I came to America and discovered the most beautiful left wing that a Marxist, today, could discover ... New York has many analogies with ancient Rome, of which Saint Paul speaks. The corruption, the hangers-on, the problem of the Blacks, of the drug addicts. And to all this Saint Paul gave a holy, albeit scandalous answer, like the SNCC [Student Non-Violent Coordinating Committee] did'. Pier Paolo Pasolini, 'Un marxista a New York: Intervista di Oriana Fallaci', *L'Europeo*, 13 ottobre 1966, reprinted in *Saggi sulla politica e sulla società*, 1597–1606, quotation at 1601.

that takes its responsibilities for translation into a contemporary idiom very seriously indeed. It is my hope that this translation of Pasolini's work into English will extend its readership and extend the horizon of discussion and debate over Pasolini's intervention into the scriptural and religious domain.

ST
PAUL

PLAN FOR A FILM
ABOUT SAINT PAUL

The poetic idea — which ought to become at the same time the conducting thread of the film — and also its novelty — consists in transposing the entire affair of Saint Paul to our time.

This does not mean that I want in any way to tamper with or alter the very letter of his preaching: on the contrary, as I have already done with the *Gospel* [*of Matthew*], none of the words pronounced by Paul in the film's dialogue will be invented or reconstructed by analogy. And since it will naturally be necessary to make a selection from among the apostolic discourses of the saint, I will make this selection in a fashion that summarizes the entire arc of his apostolate (I will be aided in this by specialists, who guarantee the absolute fidelity to the entirety of the thought of Paul).

Why would I want to transpose his life on earth to our time? It is very simple: to present, cinematographically in the most direct and violent fashion, the impression and the conviction of his reality/present. To say then explicitly to the spectator, without compelling him to think, that 'Saint Paul is *here, today, among us*', and that he is here almost physically and materially. That it is our society that he addresses; it is our society for which he weeps and that he loves, threatens and forgives, assaults and tenderly embraces.

Such temporal violence toward the life of Saint Paul, made to take place in the heart of the 1960s, naturally requires a long series of transpositions.

The first and most important of these transpositions consists in substituting for the conformism of Paul's times (or better, the two conformisms: that of the Jews and that of the Gentiles), a contemporary conformism, which will therefore be the conformism of present-day bourgeois civility, whether in its hypocritically and conventionally religious aspect (analogous to that of the Jews) or in its secular, liberal and materialist aspect (analogous to that of the Gentiles).

Such a large transposition, founded upon analogy, inevitably

implies many others. In this game of transpositions, which are mutually implicated and therefore require a certain coherence, I would like nevertheless to keep myself free. Given, that is, that my first objective is that of faithfully representing the ecumenical apostolate of Saint Paul, I would like to be able to disoblige myself, too, from a certain external and literal coherence. Let me explain.

The world in which – in our film – Saint Paul lives and works is therefore the world of 1966 or '67: as a consequence, it is clear that all of the place names need to be displaced. The centre of the modern world – the capital of colonialism and of modern imperialism – the seat of modern power over the rest of the earth – is not any longer, today, Rome. And if it isn't Rome, what is it? It seems clear to me: New York, along with Washington. In the second place: the cultural, ideological, civil, in its own way religious centre – the sanctuary, that is, of enlightened and intelligent conformism – is no longer Jerusalem, but Paris. The city that is equivalent to the Athens of that moment, then, is in large measure the Rome of today (seen naturally as a city of grand historical but not religious tradition). And Antioch could probably be replaced, by analogy, by London (insofar as it is the capital of an imperial antecedent of American supremacy, just as the Macedonian–Alexandrian empire preceded the Roman empire).

The theatre of Saint Paul's travels is, therefore, no longer the Mediterranean basin but the Atlantic.

Passing from geography to the social-historical reality: it is clear that Saint Paul revolutionarily crushed, with the simple power of his religious message, a kind of society founded on the violence of class, imperialism, and above all slavery; and therefore, as a consequence, it is clear that the Roman aristocracy and the various collaborationist ruling classes will be replaced by analogy with the modern bourgeois class that holds capital in its hands, while the humble and the downtrodden will be replaced by analogy with the bourgeoisie/liberals, the workers, the subproletariat of today.

Naturally, all of this will not be expressed so explicitly and didactically in the film! Things, characters, surroundings will speak for themselves. And from this will emerge the newest and perhaps most poetic element of the film: the 'questions' which the evangelized will pose to Saint Paul will be questions of modern men – specific, detailed, uncertain, political questions, formulated in a language typical of our time; Saint Paul's 'answers', by contrast, are what they are, that is exclusively religious, and moreover formulated in a language typical of Saint Paul: universal and eternal, but not current (in a narrow sense).

In this way the film will reveal through this process its profound thematic, which is the opposition between 'the present' and 'the holy' – the world of history, which tends, in its excess of presence and urgency, to escape into mystery, into abstraction, into unalloyed interrogatives – and the world of the divine, which, in its religious abstractness, on the contrary, descends among men, becoming concrete and effective.

As far as the composition of the film is concerned, I would think of making of it an 'episodic tragedy' (according to Aristotle's old definition) since it seems obviously absurd to recount the life of Saint Paul entirely. It will be a matter of an entirety of significant and determinant episodes, recounted in a fashion that includes as much as possible the others as well.

At the beginning of each episode, which unfolds in our time, the real date (sixty-three or sixty-four years after Christ, etc., etc.) will be written; similarly, before the credit titles of the film, for clarification, a map with the actual itineraries of Saint Paul will be substituted for that of the 'transposed' itineraries.

I list, schematically and out of order, some of the episodes which will in all probability constitute the narrative scaffolding of the film.

1 The Martyrdom of Saint Stephen

We are in Paris, during the Nazi occupation. Among the French, some are collaborationists, others protest passively, still others resist with arms (the Zealots). Saint Paul, a Pharisee, is a bourgeois profoundly interpolated in his society, by means of a long familial tradition: he is opposed to foreign domination solely in the name of a dogmatic and fanatical religion. He lives in a state of unaware insincerity, which, made to be sincere in his spirit to the point of convulsion, creates an almost-mad tension. The facts of the trial and the death of Stephen unfold exactly as they are narrated in the Acts of the Apostles – with the integration of other historical testimonies. No fact, no word will be invented or added. Only that, naturally, an ancient stoning will be treated as a modern lynching atrocity. But the dying Stephen will pronounce the same word of forgiveness. And Paul will hear it – present at the execution in order to represent official authority, which believes in its way to be liberated from the truth that comes to demolish it.

2 The Thunderbolt

As in the Acts of the Apostles, Paul requests to continue the persecution of Christians in Damascus. This is a city outside the domination of the Nazis – it could be in Spain, for example, Barcelona – where Peter and the other believers in Christ are taking refuge. The traversing of the desert is like the traversing of a symbolic desert: we are on the streets of a large European country, the countryside of the south of France, and then the Pyrenees, and then Catalonia, lost in the abyss without hope because of the war – in a silence, which can be made real and tangible by rendering the soundtrack of the film completely mute: in this way, to create fantastically and in a fashion still more anguished than reality, the idea of the desert. In any of these grand streets full of traffic and

the usual acts of everyday life, but lost in the most total silence – Paul is seized by light. He falls, and hears the voice of his call.

He arrives blind at Barcelona. There he meets Ananias and the other Christian refugees; converted, he unites with them; he decides to retire to meditate in the desert.

3 The Idea of Preaching to the Gentiles

It is that which in 'screenplays' is called 'consequence', Paul turns toward his new friends, already holy, fascinated by an impulse of love and inspired will, when his own idea overturns the situation and creates new and terrible difficulties and completely new perspectives: it is a true revolution within a revolution. I would like to reconstruct the concrete moment (even by inventing it, if a direct testimony does not exist) in which the new inspirational light descends upon Saint Paul.

It begins like this – and we see it in the first acts – this apostolate which is 'a scandal for the Jews, folly for the Gentiles' [1 Cor. 1:23].

4–5–6 Adventures in Preaching

A series of three or four 'typical' episodes from the first part of the preaching: 'typical' and thus also representative of an entire series of other episodes that cannot be narrated. By the series of episodes of evangelization of people belonging to the well-to-do and cultivated classes, the preaching at Athens (which we have said would be replaced, by analogy, by modern Rome, sceptical, ironic, liberal) could be selected; while by the series of episodes of evangelization of simple people, two stories could be selected, one that concerns workers or artisans, the other the most filthy and abandoned subproletariat: or rather the story of the makers of silver 'souvenirs' in the temple (I think) of Venus, who see

their profits diminish as a consequence of the discrediting of this temple, a destination for pilgrims; and the story of that group of poor devils who, in order to scrape together a living, pretend to know how to expel demons from those possessed by demons, as Paul and in the name of Paul, while they don't succeed at this, and come to a bad end, etc., etc.

7 The Dream of the Macedonian

The episodes that I have described in the previous paragraph could all take place in Italy: now Paul proceeds toward the North. The dream of the Macedonian can be thus replaced by analogy with a 'dream of the German'.

Paul sleeps one of his painful sleeps of illness, which reduces him to lamentation as if in a delirium. And it is here that, in the deep peace of the dream, a most beautiful figure appears to him: a young German: blond, strong, youthful. He talks to Paul, he demands that he come to Germany: his call, which lists the real problems of Germany, and with which Germany needs help, sounds unreal 'inside' that holy dream. He speaks of neocapitalism, which satisfies only the material well-being, which withers; of the Nazi revival; of the substitution of blindly technical interests for the ideal interests of classical Germany, etc., etc. But, while he speaks like this, this blond and strong young man, little by little – as if something external to him is physically representing the interiority and the truth – becomes ever more pale, overcome, devoured by a mysterious illness: slowly left half nude, horribly thin, he falls to earth, curls up: he becomes one of the dreadful living carcasses of the concentration camp ...

As if this dream were continuing, we see Saint Paul who, obeying this desperate call, is in Germany: he walks with the swift and secure steps of the Saint, along an immense highway that leads toward the heart of Germany ...

Plan for a Film about Saint Paul

(I am prolonging this point because it is here that the theme of the film, in a fantastical visual mode, is grounded – that will be above all developed in the final part of the film, the martyrdom in Rome/New York: that is, the contract between the 'present' question addressed to Paul and his holy 'answer'.)

8 The Religious and Political Passion from Jerusalem to Caesarea

Paul is again at Jerusalem (Paris). Here begins that concatenation of violent and dramatic episodes, which are so well-known that one ought to sum them up rapidly: it involves a series of the most dramatic sequences of the film – that conclude at Caesarea (Vichy) with Paul's request to be judged at Rome.

9 Saint Paul at Rome

This is the longest and richest episode of the film. In New York we are in the belly of the modern world: there the 'presentness' of problems involves violence and an absolute obviousness. The corruption of the ancient pagan world, mixed with the uneasiness deriving from the confused feeling of the end of such a world – is replaced by a new and desperate corruption, which is to say the atomic desperation (neurosis, drugs, radical social conflict). The state of injustice that dominates in a slave society like that of imperial Rome can be symbolized by racism and the condition of blacks. It is the world of power, the immense richness of monopolies, on the one hand, and on the other, of anguish, of the will to die, of the desperate struggle of the blacks, whom Saint Paul happens to be evangelizing. And the more 'holy' his answer, the more it upsets, contradicts, and transforms the present reality. Saint Paul ends up thus in an American prison, and comes to be condemned to death. His execution will not be described naturalistically (replacing, as

usual, by analogy, decapitation with the electric chair): but it will have mythic and symbolic qualities of a remembrance, like the fall in the desert. Saint Paul will suffer martyrdom in the middle of the bustle of a suburb of a large city, modern to the breaking-point, with its suspension bridges, its skyscrapers, its immense and crushing crowd, which passes without stopping in front of the spectacle of death and continues to whirl around, through its enormous streets, indifferent, hostile, without meaning. But in this world of steel and cement, the word 'God' resounds (or starts to resound).

OUTLINE OF A SCREENPLAY FOR A FILM ABOUT SAINT PAUL (IN THE FORM OF NOTES FOR A PRODUCTION DIRECTOR)

1. Paris. Various exteriors. (Day and night.)

As it emerges from the plan of the film, which preceded these notes, ancient Jerusalem is replaced by Paris, in the years between 1938 and 1944, that is, under Nazi occupation. The ancient Roman dominators are thus replaced by Hitler's army, and the Pharisees are replaced by the conservative and reactionary class in France, among whom naturally are the collaborators of Pétain.

The film begins with a description of Paris in this period.

Archival footage will be used.

(The first images will not need to be excessively dramatic: It will be necessary to carry out accurate research in the archives, in order to find cinematographical documents that describe as well as possible the 'daily life' of Paris in those days: the semi-deserted streets, the hunger, the fear, the free time of the German soldiers, small 'slices of life' marked by anguish and by death.)

2. Paris. Interior. (Twilight.)

We are in a small Parisian interior (which can even be reconstructed from theatrical sets.)

It is a matter of a petit bourgeois apartment, with its dignity, its taste, its poverty, etc. Things that were in fashion in those days, etc.

The windows are half-closed, but it feels like they face onto one of the narrow streets of an ancient quarter in the centre of the city.

Here are gathered (as in a clandestine meeting of the Resistance) the twelve apostles. Some are dressed like petit bourgeois intellectuals, other like workers – in the clothing of those days.

Together with the twelve apostles, squeezed inside with them – in their eyes the light of vanquished fear, of necessary prudence, of pain, of the will to struggle which consumes them – there are many other men and women: it is, then, physically, a meeting of partisans.

In the profound silence the voice of the apostle Peter rises:

'It is not right that we lose sight of preaching and the announcement of the Word in order to serve tables.

'Choose seven of you, who are seven reliable people, decent and honest men: and we will appoint them to oversee this loving service for the poor.

'We, we will continue to have in mind the divine service and the preaching of the Word.' (Acts 6:1–8:3)

3. Paris. Large cellar. (Night.)

(This environment can also be reconstructed from theatrical sets.)

The assembly – formed primarily from the same people who were present at the previous meeting – are electing the 'decent and honest men', assigned to help the poor (a partisan organization, then, in its minor functions, precisely organizational).

The seven deacons (or young partisans, if one prefers) are elected: Stephen, Philip, Procoros, Nicanore, Timon, Parmena, Nicholas (an Englishman, perhaps escaped from Dunkirk and unsuccessful at returning by boat to London, which can replace Antioch).

(Required therefore for this scene are sixty extras, from among whom the deacons are carefully selected.)

4. Paris. Interior. (Daytime.)

We are in the same apartment as the first meeting.

The seven deacons come to be presented to the heads of the 'partisan organization', Peter and the others.

Everyone prays together.

There will be a long close-up on the face ('full of faith and strength') of the partisan Stephen – who is the youngest, a boy not yet at the age of conscription.

5. Paris. Street. (Day.)

This will be one of those terrible streets in Paris – already seen in the first silent documentary images – where daily life, dominated by death, unfolds.

Stephen ('full of grace and truth') is engaged in a partisan action (to establish it, background documentation: reprovisioning of foodstuffs, or arms, etc.).

Some people (whom we suppose to be spies) observe him (but this will remain ambiguous).

The SS (or a group of French military collaborationists) overtake him – with the atrocious speed of misfortune.

The struggle is tragic and short. Destiny is accomplished on time. Stephen is arrested, sequestered, taken away. (Acts 6:1–8:3)

6. Paris. Tribunal. (Day.)

(It remains to be established whether a military tribunal or a civil one is involved here. In any case, this replaces the Sanhedrin.)

For that which concerns the organization: the group of judges, twenty French military collaborationists, then several SS soldiers. A crowd of witnesses and fascists – as well as some wretched people, sold to them, by terror and miserable calculation – which in years such as those, made man so much worse than himself.

In sum, eighty people in total.

On the dock of the accused is Stephen, manacled.

The witnesses follow:

'We have heard him blaspheme against God.'

'This man never stops attacking the holy place and the law.'

'We have heard him with our own ears say … that the customs that our fathers have handed down to us will be changed.'

Internal dissolve between each remark.

('But, fixing their eyes on him, those who sat in the Sanhedrin saw that his face was like that of an angel.') (Acts 6:1–8:3)

Finally it is the turn of the High Priest (the President of the Tribunal):

'Is it true what is said against you? What have you to say in your defence?'

Stephen responds (see the cited chapter of the Acts of the Apostles), concluding with the following words:

'But you, stiff-necked men, uncircumcised of heart and ears, you continue your resistance to the Holy Spirit. Like your fathers, so do you. Which prophet did your fathers not persecute? They killed even those who prophesied the coming of the Just One, the one of whom you are the betrayers and assassins.

'You have received the law from the hand of angels, but you have not observed it.'

The explosion of 'fascist scandal' follows in the room, with its rhetoric, its horrid indignation, etc., its profound and macabre stupidity, etc. (The Public Minister who pounds his hand on his bench like a drunk middleman, etc.)

But the voice of Stephen, although it is barely audible, surpasses this victorious clamour:

'Behold, I see the heavens opened, and the Son of man, standing at the right hand of God.'

('Those men, bringing their hands to their ears, gave out a cry; then they hurled themselves upon him, dragging him outside …')

7. Paris. Exterior. (Day.)

It is one of those places, so familiar to our terrorized memory and our dreams, in which shootings took place between 1938 and 1945. A plaza, an interior courtyard of some prison, the open space in front of a school. (It remains to be decided: the location

visits will decide it. It is certain, though, that the place should be found in Paris.)

Everything is from the point of view of Paul. The scene begins therefore with a long close-up on him. He is a young man only a little older than Stephen, that is, twenty-five to thirty years old. Whatever his face might be, it is the face of one hardened by fanaticism, that is, by that will that possesses men in certain moments in history to be less than themselves.

In the face of Paul we see something worse than evil: we see cheapness, ferocity, the decision to be abject, hypocrisy that motivates everything in the name of the Law, of Tradition – or of God. All this cannot but render that face desperate, too.

In any case, before his eyes – with a villainous speed that takes away the value of life – the shooting occurs:

The execution squad passes quickly in front of Paul, with the condemned in front of them. He is pushed against the wall; blindfolded; his last words are barely heard ('Lord Jesus, welcome my spirit'); then the shot, which does not kill the adolescent martyr, who in martyrdom becomes almost a boy; he falls wounded in his own blood; one of those close to him, shooting him in the neck to finish it; still his words can barely be heard ('Do not blame them for their sin'); then the shot, and the death – the butchered flesh.

Paul – among several other 'Pharisees' with him – powerful bourgeois, authorities – look at the cadaver of the child with desperate, revolting, guilty bitterness.

8. Paris. Various exteriors. (Day and night.)

'There was as though a signal for persecution … ' (Acts 6:1–8:3)
New archival documentary material.

But this time it must be found from among the most terrible, almost unbearable to watch: arrests, raids, shootings, hangings, mass deportations, mass executions, shootings in the streets and

the plazas, corpses abandoned on sidewalks, under monuments, dangling from lampposts, hanged, hooked.

Departures of the Jews for the concentration camps; freight cars filled with corpses.

Moving in the same style as these documentaries, several scenes follow in which Paul's intervention in business, like that described above, is shown: he will appear foreshortened, almost randomly (as if he were an anonymous and forgotten person from the 'archival material').

He will drive through the city – among the arrested, the hanged, the shot, etc. – among French collaborationist soldiers and divisions of the SS – in automobiles or in jeeps from those documentaries: in short, 'Paul in the meantime spread fear, stoking the hunt for the faithful: he rummaged houses, broke into synagogues, dragged out men and women, chained, throwing them in prison ...' (Acts 6:1–8:3)

(These scenes in 'documentary style' will of course play out on the real streets and plazas of Paris. There will need to be at least fifty extras.)

9. Paris. Interior. (Day.)

The same apartment where the clandestine meeting of apostles took place. Everything is empty, deserted, in disorder: the abandonment of the rooms was obviously sudden and precipitous.

The old furniture made for the quiet of an honest family life, the little everyday things, the blankets, the pans, the small pictures on the walls; in the silence and the light that invade the emptiness are the mute signs of tragedy.

36 A.D.

10. Paris. Office of a military command. (Day.)

'If any other one believes himself to be able to have confidence in the flesh, I do more than everyone. Circumcised on the eighth day, of the people of Israel, of the tribe of Benjamin, Hebrew of the Hebrews, Pharisee as to the law, as to zeal a persecutor of the Church, irreproachable as to justice/righteousness, which is founded upon the law ...' (Acts 9:1–30) [Phil. 3:4–6]

Paul pronounces these words – with his face fanatical with fascism – before a leader worthy of him: a tall official of the army or a powerful bureaucrat. How he smiles, like one accomplice to another, like a stupid and savage father at a stupid and savage son – and he says to him:

'Here are the credentials for Damascus with the agreements with the synagogues there authorizing you to make arrests and to bring prisoners here to Jerusalem, as many disciples of this movement that you find, men and women ...'

Paul takes the credential letters and with a hateful smile (naïve and desperate) says goodbye and leaves, crossing the luxurious office in which the rulers are encamped.

11. French province. Exterior. (Day.)

The scene involves several 'passages' across occupied France, in the direction of Spain.

In a big black car – the car of authority, followed by a small escort – the young Paul is headed toward Barcelona (Damascus).

The countryside, with its small deserted villages, the small provincial cities that live their tragedy in silence: armed men everywhere, women, old people, children – desperate and silent – everywhere.

And then the long deserted roads toward the border, with the Pyrenees vaguely threatening like a lifeless wall against the horizon.

Paul suddenly feels ill, brings his hand to his forehead and faints.

The car stops; the escort gathers around him, alarmed; the driver opens the door to allow air to pass through, etc.

But Paul doesn't rouse himself, he is lost in his illness, even though his eyes are half-open and he seems to be conscious.

A voice resounds (which only he can hear):

'Paul, Paul, why do you persecute me?'

And Paul responds to it, as in a delirium:

'Who are you, Lord?'

The driver and the small, armed escort don't understand what is happening.

God:

'I am the Jesus whom you persecute. But now get up, go into the city and you will be told what to do.'

Paul remains like this for a while, listening to a voice that speaks, which only he can hear (to the dismay of his men). Then he recovers, *but he is blind*.

Blind and dazed, he again embarks on the journey toward the border.

Before his blind eyes, the Pyrenees pass with their crossings, their deserted pastures; then the border and the first villages on Spanish soil. Before his blind eyes, the Catalan countryside appears, the sea, the outskirts of Barcelona – Barcelona ...

(These scenes, then, all taken from real life, shot in the places listed above. Paul and his escort are the only 'fictional' characters. As for the passages, the city and the people, they will be selected for their ability – even if not in an absolute sense – to recall the end of the 1930s and beginning of the 1940s.)

Outline of a Screenplay

12. Barcelona. Narrow Alley. Exterior. (Day.)

The big black car stops in front of a large and luxurious hotel in Barcelona, facing an old alleyway. Paul gets out, still blind, and is led by the hand inside the hotel.

(Cf. the note on the preceding scene.)

13. Hotel room in Barcelona. Interior. (Day.)

Still led by the hand, like a child, Paul, blind, enters his room, and sits down next to the window.

Internal dissolve.

Paul is now seated in front of a table. He is still blind. He is served dinner. But he does not allow himself to be convinced to touch the food. He remains immobile, looking in front of himself with his blind eyes.

(This hotel room can be reconstructed from theatrical sets.)

14. House of Ananias in Barcelona. Interior. (Day.)

Ananias (an exiled French partisan) is sleeping on his mat (the room where he lives is probably a sublet room in a small apartment in the centre of the city – one hears from the alley, the racket of workers, sailors, prostitutes).

Over the sleeping body of Ananias one hears a voice. It is God.

'Ananias!'

'Here I am, Lord!'

'Get up, go to the alley called Narrow Alley, and look in the house of Juda for one from Tarsus, named Paul, who is praying and already sees you with his spirit while you are going to lay hands upon him and restore his sight.'

'Lord, I have heard many tell of the evil that he has done to the saints in Jerusalem, never ceasing to hunt them down, like a dog;

and he has even come here with the intention and the power to enchain whomever he finds who invokes your name.'

'Go, as I tell you, to this man whom I have chosen as a fit instrument to make my name known to the Gentiles, to the kings, and to the children of Israel. I will show him how much he has to suffer for my name.'

(Ananias's tiny room can be reconstructed on a set. The exterior of the poor alleyway of Barcelona can be shot on-site, passing through the interval from exterior to interior.)

The voice of the devil who pretends to be God.

Scene among the devils.

15. Barcelona. Narrow Alley. Exterior. (Day.)

Ananias walks uncertainly along Narrow Alley, arrives in front of the hotel where Paul is staying, and enters, fearful (like one who is persecuted), the large 'hall', where the masters and their servant-dogs who protect them are staying.

(Exterior and interior are related: the scene will be filmed in Barcelona, in a real place.)

16. Hotel room in Barcelona. Interior. (Day.)

Ananias enters the room where Paul, standing, awaits him, holding his chin up, as the blind do.

'Paul, brother, the Lord sends me to you, the Jesus who appeared to you the day before yesterday on the road by which you came. He wants you to recover your sight and to receive the holy spirit.'

Paul, suddenly, sees. He touches his eyes – as if still disoriented by the terrible trauma – and looks around, sternly.

Ananias baptizes him.

17. A large room in Barcelona. Interior. (Night.)

It is a meeting of antifascists in exile.

Accompanied by Ananias, Paul arrives among them, at the table where the leaders of the clandestine movement are talking.

Those present are amazed by this, and wonder:

'But is he the one who exterminated the worshippers of this name?'

'And didn't he even come here to hunt the faithful and drag them, enchained, before the high priests?'

At this point the notes of the first musical soundtrack of the film are heard (it is a revolutionary song – perhaps the same one that accompanies the first moments of Christ's preaching in The Gospel According to Matthew*).*

Those present at the meeting continue with their comments – which now are of a modern, historical, present-day character:

'Isn't he a fascist?'

'A collaborator with the SS?'

'Isn't he a fanatic, a willing and exalted servant of power?'

'Isn't he, and didn't he declare himself the most zealous of the most zealous promoters of the traditions?'

'And aren't the traditions for him authority and hate, racism and discrimination?'

Bit by bit the murmurings of the assembly calm down, and in the big room where the exiles are meeting, silence falls.

Paul looks around and begins to speak (he has a mysterious smile, unbelievable in that face distorted by fanaticism), and looking around humbly, he says in a deep voice, in the way the first words of a hymn are uttered:

'Christ has liberated us for freedom.'

18. Hotel room in Barcelona. Interior. (Night.)

Also in the room where Paul was staying, is a meeting – of fascists. The high official or high bureaucrat who gave the credential letters to Paul in Paris participates. There are also Falangists, in uniform. And some horrible faces of servants, armed like gangsters, the subproletariat *Sicarii* of the triumphalist bourgeoisie.

19. Ananias's house in Barcelona. Interior. (Night.)

Paul and Ananias share the same poor little room and the same bed: they sleep, one at the head and one at the foot.

But then there is frantic knocking at the door.

Ananias gets up and goes to open it.

Paul hears him conferring secretly and anxiously in the corridor with a young man.

At the end of these excited discussions, Ananias turns toward Paul: anguish and resignation, terror and the sense of inevitability are mixed together in his good eyes.

Paul has understood: he gets up, dresses quickly, snatches up his meagre belongings: then, followed by Ananias, he flees the room.

20. Alley of the house of Ananias. Exterior. (Night.)

The two companions flee, in the midst of the chaos of the alley, among the little bars of the seaside city, with the lights on in the middle of the night, songs, etc. The comings and goings of sailors and drunks, the laughter of whores, etc.

Ananias:

'What do you propose to do?'

Paul:

'I will not consult with flesh and blood, and I will not travel to Jerusalem near those who were apostles before me, but I will go into the desert ...' [Gal. 1:16–17]

21. Against the sky. Exterior. (Day.)

An old, noble, mysterious man, with a face marked by physical fatigue and clear, extremely mild eyes, speaks directly at the spectator of the film:

'No desert will be more deserted than a house, a plaza, a street where people live in the 1970s after Christ. Here is solitude. Side by side with your neighbour, dressed from the same department stores as you, customer in the same stores as you, reader of the same newspapers as you, spectators of the same television as you, there is silence.

'There is no other metaphor of the desert than everyday life.

'This is not representable since it is the shadow of life: and its silences are interior. It is a blessing of peace. But peace is not always better than war. In a peace dominated by power, one can only protest by not wanting to exist.

.

'I am the author of the Acts of the Apostles.'
Diabolical discourses
(passage of three years in the desert).

22. Streets of Paris. Exterior. (Day.)

Paul is 'led by the hand of Barnabas' through the streets of Paris: still deserted, lost in the odour of war's death, etc.

They pass in front of the Sorbonne.

They look at the school where they had studied together.

They pass through other streets of old Paris. They arrive in front of an anonymous house, with small shops below, and enter.

Reappearance of 'sick' Paul.

23. House of clandestine meeting in Paris. Interior. (Day.)

Inside the house (similar to the one where we saw them meeting clandestinely the first time), there are the apostles and their disciples (a meeting always analogous to one of the FLN) [Front de Libération Nationale/National Liberation Front of Algeria].

Barnabas introduces Paul to Peter and the others: 'Do not look on him with suspicion: the Lord appeared to him and spoke to him on the street in Damascus, and here in the city he has preached boldly in the name of Jesus ...'

Peter, suspicious, out of duty (as a leader of the partisans confronted by a new unknown comrade) asks:

'Why do you do it?'

A long close-up of Paul (profoundly marked by his meditation in the desert, which lasted three years – and perhaps already tormented and deformed by his mysterious bodily illness), who speaks, illuminated, and says:

'If I evangelize, it is not for me an advantage ... I do it because it is absolutely necessary for me to do it. Woe to me if I do not evangelize!' [1 Cor. 9:16]

Dissolve on Peter's brotherly smile.

24. Paris. Notre-Dame or some other large church. Interior. (Day.)

(There will first be a full shot of Notre-Dame seen from the outside.)

Paul is kneeling down on a bench, immersed in prayer.

Next to him is Barnabas.

The profound silence of the cathedral is broken by a weak, intermittent uproar: gunshots, perhaps, or a distant bombing. It is barely perceptible, yet nevertheless terrible.

Abruptly Paul interrupts the concentration of prayer as if he had suddenly seen or heard something. And in fact a voice (heard only by him) reverberates:

'Hurry and leave the city, because your testimony on my behalf, here, will not be heard.'

Paul responds to the voice of Christ:

'Lord, these people know that I went from synagogue to synagogue to arrest and enchain those who believed in you; and when the blood of your witness Stephen was shed, I also was present, among the killers …'

And the voice of God:

'I will send you far away, close to the nations of the Gentiles …'

Paul is again mute, contorted, and the voice of God has barely stopped resonating when, from the bottom of the door of the immense cathedral, a group advances, two or three people, in a hurry, agitated, as ones who are in a terrible haste, or driven by fear.

These people come close to Paul and Barnabas who are praying, and bring their news with a frightened air:

'They are on your trail, Paul, and they are looking for you …'

'They searched the house where you live …'

'You have to escape, to hide …'

Etc.

Barnabas, more practical than Paul in these matters – having been persecuted like this for some time – makes the decision that seems to him the most correct:

'You should return to Tarsus, the city where you were born, among your own people … You will be hidden there … they will not find you … etc.'

All together, they go, almost running toward the door of the church, through which a beam of dazzling sun enters into the painful semi-darkness: the weak, remote sounds of bombardment continue to echo.

25. European city. Interior – exterior. (Day.)

Seen from the outside, the house where Paul lived as a boy, which presents itself immediately as the house of very rich people, very respectable and also very discreet. No exterior luxury, no waste: it could be an Art Nouveau building, of good taste, etc., with a garden in front, surrounded by discreet walls or wrought-iron gates, etc.

A magnolia tree, in a slightly humid corner, reaches to touch a large window on the second floor: it is the window of Paul's studio.

The interior is like the exterior: built and furnished in an epoch of bourgeois bad taste, yet with a certain feeling for the life that had to have dominated the masters of the house – that is, the parents of Paul. In everything there is a certain severe grace.

Paul is seated at his old desk (tall, substantial, walnut, carved); he is pale, contorted, tired, with a long beard, weak, exhausted.

He is caught in the grip of his physical malady, which causes him to suffer dreadfully.

With his face contorted so, he is fixed upon two photographs (both with dedications to him from his parents): one shows two rich bourgeois, smiling and full of an ancient dignity, his father and his mother. The other shows himself as a child: a student in the first or second grade, with a medal and a ribbon pinned to his chest.

Then, as if to seek relief, he gets up from the chair and, almost staggering, goes toward the big window, looking outside.

The house is clearly on the crest of a hill, since a large part of the city, sloping down toward the port, appears from the window.

The sea shines, blue and vacant – far away.

Boats and ships plough through it.

Seeing the city of his birth at his feet, Paul has a weak, discouraged smile, and mumbles in a fashion barely audible:

Outline of a Screenplay

'I am a Jewish man, from Tarsus, citizen of a city not unknown in Cilicia ...' [Acts 21:39]

On the same street where Paul's parents' villa rises, there is a school, a gymnasium. It is noontime (the bells and sirens sound): the children begin to exit the school, which is obviously (or mysteriously) the same one that Paul frequented as an adolescent. It is a school of rich children; this is apparent. And while they swarm, waiting for them outside the door of the gymnasium are the mothers, calm and elegant, who have precisely the appearance of rich bourgeois ladies; meanwhile, drivers wait for the children of their masters, near their cars.

One of these young men can be seen: a handsome and pale boy, closed in on himself, dressed almost exactly as the child Paul in the photograph, who, without a smile, follows a driver, who opens the door of the dark car for him, and respectfully helps him enter. He makes himself comfortable, always serious in the big seat, resting the books rigidly on his knees.

Paul observes this fleeting scene, identical to those in which he was the protagonist at one time, so many times before – he recognizes himself in that serious and almost gloomy boy. Just then, a disconsolate smile sadly illuminates the face of the sick man, and he mutters bitterly, but in a fashion barely audible, to himself:

'Circumcised on the eighth day ... of the people of Israel ... of the tribe of Benjamin ... Hebrew from the Hebrews ... Pharisee in relation to the Law ...' [Phil. 3:5]

He moves away from the window, and although suffering, passes through the whole house (which, just by following him, we will discover and describe), goes out the service door, passes through the garden and enters some sort of out-building, next to a greenhouse. This 'out-building' is an artisanal laboratory, outfitted for the production of manufactured textiles. Paul positions himself at a loom and, absorbed and sad, he begins to work.

Then, suddenly, as if struck by lightning, Paul is knocked over and falls to the ground, remaining immobile, without a sign of life.

26. European city and Heaven. Interior – exterior. (Day.)

In this scene will be described, by means of a technique still to be established – perhaps with a photographic trick, etc. – the 'abduction to the third heaven' of Paul.

Probably a vision of a dream: reappearance of a childhood place, with plants, birds, insects, water: a humble realistic 'terrestrial paradise'.

27. European city. Paul's studio. Interior. (Day.)

Paul is reading in his studio. He is still suffering, devoured by illness, humbled by God.

An attendant enters, and announces a visitor.

Paul raises his eyes questioningly and, in this luxurious studio and in the half-darkness, Barnabas enters.

The two friends, moved, embrace each other for a long time in silence.

Then Barnabas:

'You should come with me to Antioch. The faithful who became exiles because of the persecution unleashed after the martyrdom of Stephen, ended up in Phoenicia, in Cyprus, and in Antioch. It profited them to announce the good news; but limiting themselves only to the Jews. But some of them, who are Cypriots or Cyrenean, and have gone to Antioch, they are preaching even to the Greeks!

'The power of God was with them, and they are successful in converting a good number of them.

'The news arrived in Jerusalem, and the disciples have sent me to Antioch.

'I saw the work of grace and I delighted in it, and I exhorted everyone – Jews and Gentiles – to stand united in the faith in the Lord, with patient heart.

'Behold, and now I came to take you, to bring you to Antioch, to continue together ...'

At Barnabas's words, Paul's face is illuminated: and with the light, the strength of a man of action is also returned to him, the energy of a missionary, of an apostle of the new Law. It is true that the light that illuminates him comes from the memory of the voice of God that resounded for him in the temple ('I will send you far away, close to the nations of the Gentiles'): in any case, the zeal that is reborn in him is now the zeal of a priest and not of a saint.

Concepts expressed by a new intervention by Satan and his instigator.

The devil 'Instigator' imitates the voice of God, which utters the sentence that appears on p. 36 [in scene 29].

28. Geneva. Station. Exterior. (Day.)

Paul and Barnabas get off the train, which is stopped at the station in Geneva (Antioch): dressed modestly but with dignity, like bourgeois who have a certain traditional idea of dignity.

They descend from the railcar, with an inspired air of those bound to do great things; passing through the crowd – pulling behind them their light luggage.

They exit the station at a vigorous and speedy pace and are lost in the large plaza in front.

Dissolve.

45 A.D.

29. Geneva. Exterior. (Day.)

On the banks of the lake, Paul, Barnabas, Simon called 'the Black', Lucius of Cyrene and Menachem, childhood friend of Herod the Tetrarch (Acts 13:1–14:28) are praying. Around them is a large crowd of the faithful (200 or 300 people), who follow them in their prayer, like people returning from a procession – or at the end of a holy meeting.

Suddenly the voice of God is heard:

'Leave Barnabas and Paul available for the mission for which I have destined them.'

The light of vocation burns ever stronger in the eyes of Barnabas and Paul.

30. Marseille. Port. Exterior. (Day.)

Paul, Barnabas, and a third missionary, John called Mark, are at the port of Marseille (Seleucia), waiting to embark (Acts 13:4–13).

Their eyes burn with strength and hope.

A crowd of passengers, sailors, porters swirls around them, but none seem to have sense or sound. Bursting, raging music is heard:

Musical soundtrack of the revolutionary song already heard in scene 17.

Internal dissolve.

With the same musical motif always in the background, Paul and the others are now embarking on a large ship, getting lost among the other passengers on the deck.

Internal dissolve.

Now the ship, amidst the roar of sirens, moves away from the wharf and begins slowly to enter the open sea.

Internal dissolve.

Outline of a Screenplay

The ship is already far away, sailing toward the high seas.
Internal dissolve.
The ship is but an imperceptible point on the blue.
Fade.
(This scene will be filmed in real life, 'stolen' as one says in cinematographic jargon: therefore extras are not necessary, but only the three actors.)

Add a scene in hell in which Satan instructs his instigator to be incarnated as Luke, who, at the end of writing his gospel, prepares to write the 'Acts' (and Satan exhorts him to write in a false, euphemistic, and official style).

The next scene (31) begins with Luke's arrival in the street: with him we enter the meeting room; and by the voices that greet him we know that it is Luke; and finally by his fierce smile, hidden in a mirror, it is confirmed for us that the instigator of Satan is incarnate in him.

31. Clandestine meeting room in Paris. Interior. (Day.)

A group of 'revolutionary' Christians are gathered in the room. Among them, the most important of the apostles, the leaders, Peter and the others.

But at the centre of attention is John called Mark. Also present, attentive (but at the same time detached and absent) is the author of the Acts, Luke.

Anxious, they all make a circle around Mark, and they ask him:
'Why did you come back? Why did you leave Paul? Etc.'
Mark:

'Yes, he has certainly done great things! I remember Paphos – we'd barely arrived – when we found the proconsul Sergius Paulus, an intelligent man ... who had in his service a magician, a Jewish false prophet, a certain Bar Jesus ... Well, Paul, staring into his eyes, confused this sack of malice, fabricator of frauds and

intrigues ... and rendered him blind ... and the proconsul, shaken by the prodigy, believed in Christ ...

'From Paphos we embarked and arrived at Perga, in Pamphylia ... and it was there that I detached myself from him and left him ...'

'But why, why did you do that?'

'I know that he was going from Perga to Antioch, and he spread the word of Christ there, so that the people coming out of the synagogue asked him to speak every Sabbath ... And many Jews and good proselytes were near to Paul and Barnabas, who exhorted them to persevere in the grace of God ... And I know also that, seeing so much success, the Jews were consumed by jealousy, and showered insults on Paul and his words ... And Paul shouted at them:

'"The word of God ought be announced to you, first before others. But since you reject it and do not believe yourselves worthy of eternal life, *we will turn to the Gentiles* ..." [Acts 13:46]

'Do you understand?

'And he added: "Thus has the Lord commanded us: I have made you as a light to the nations, because you carry salvation to the ends of the earth!" [Acts 13:47]

'Naturally, in hearing this, the Gentiles rejoiced, exalting the word of God: and everyone, satisfied, believed it.

'Then, chased from there by the Jews, Paul and Barnabas went to Iconium: and even in Iconium, many Greeks, Pagans, non-elect, embraced the faith ...

'And just so in Lystra, in Derbe and in the surrounding areas ... And then, persecuted and chased also from there, again to Iconium, to Antioch ... They named an elder for each of the churches they founded, including even the Greeks, the pagans, the non-elect ...

'Always persecuted and threatened with death, stoned – one day Paul was even believed dead! – they traversed Pisidia, they came to Pamphylia, preaching, founding other churches ...

Outline of a Screenplay

'And finally they returned to Antioch in Syria ... At their arrival the churches came together and recounted the great things that the Lord had done with them, opening the doors of faith even to the Gentiles – the pagans, the non-elect!' (cf. Acts 14:21–15:2)

'So you left Paul because he preached the word also to the Gentiles, the non-elect?'

'Yes, it was for this! What Paul does is a scandal!'

Peter – furious, tense, 'scandalized' – listened to this speech. And almost shaking with pain and anger, he says:

'We have to hear Paul on all these things.'

Luke observes with a furtive sneer.

32. Luke's studio. Paris. Interior. (Day.)

Shoulders foreshortened – almost unrecognizable – Luke is writing, hunched over a small writing table – in one of those Parisian interiors, which face out onto old buildings, on narrow streets in old neighbourhoods.

He writes, with his ironic sneer imprinted on his features: his writing is elegant, neat, precise, and without regrets.

'At their arrival in Antioch, the church met and recounted, first one and then the other, the great things that the Lord had done with them, opening the doors of faith even to the Gentiles ...

'Some Christians who came from Judea hinted to the non-Jewish brothers: "If you are not circumcised according to the custom of Moses, you cannot be saved." Dissension and discussion with Paul and Barnabas arose about this. Then it was decided that the two apostles should go up to Jerusalem to consult the elders on this pressing question ...' (Acts 15:1–35)

Having finished drawing up these lines, Luke, as if roused and returned to reality, gets up in a lively way, belches and leaves the room.

33. Streets of Paris. Exterior. (Day.)

Still seen from the back, enough so that one almost doesn't recognize him, we follow Luke, who walks quickly through the streets of Paris (still immersed in the anguished atmosphere of war). He arrives in front of the house of the 'clandestine meetings', and cautiously, looking around, afraid, he slips through the doorway.

34. Clandestine meeting room in Paris. Interior. (Day.)

A grand confusion greets the 'possessed' Luke. A confused clamour, a sudden rise of angry cries, pleadings, resentments, exclamations of scandal. Fifty people (elders and apostles) are engaged in their 'serious arguments' (Acts 15:1–35), and the clamour in the room is deafening.

As in a clip of 'cinema-verité', behind their shoulders and necks, their faces lit up and screaming in close-up, Luke sees Paul, Peter, and the others, immersing themselves in a violent argument, in the back of the room, far away. Paul and Peter are facing each other, frowning and indignant like two adversaries.

Dissolve.

(The scene will be shot on set, cf. above.)

35. Luke's studio. Paris. Interior. (Day.)

Hunched over, from the back, mysterious, ironically taken up by his meticulous loyalist and hagiographic inspiration, Luke continues drafting the Acts, in his beautiful handwriting:

'... At Jerusalem they were received by the elders and the apostles, to them they exposed the great things that God had done with them everywhere. Some converts from the party of the Pharisees – thus of strict observance – expressed the opinion that the pagans,

Outline of a Screenplay 37

coming to the faith, ought to be circumcised, devoting themselves then to the observance of the Mosaic law.

'The apostles and the elders gathered separately to study the question better, having a series of discussions … ' (Acts 15: 1–35)

36. Clandestine meeting room in Paris. Interior. (Day.)

In the room, now, there is much more calm, indeed, too much calm. Everyone is seated in a circle around the leaders: but the faces are discontented, troubled, impatient – or else simply resigned.

Peter gets up and takes the floor, laboriously, as if every move is an effort (for diplomatic reasons and yielding for the good of all):

'Brothers, you know that from the first days, God chose me to bring to the Gentiles – to the non-elect – the gospel that introduces the faith.

'And God who knows hearts, helped them, giving them the holy spirit like us Jews: and he made no distinction between us and them, once their hearts were purified by faith …' (Acts 15: 1–35)

The assembly listens in great silence to this admission.

The 'Pharisaic' face of Paul is radiant and triumphant.

James gets up (he, too, like Peter, but more conciliatory):

'Brothers, listen to me. It is true that ever since the old days, God has chosen a people among the pagans and consecrated them to his name. But in the oracles of the prophets it is also written: "After this, I will rebuild the house of David which is like a smashed tent: I will reconstruct its ruins and I will set it again on its feet, in order that even *the other men* may seek the Lord …"

'For this reason I think that we ought not create too many obligations for those who come to God from paganism. Rather we

should notify them in writing about the things from which they ought to abstain ...' [Acts 15:13–20]

Paul is still radiant and triumphant: Luke smiles and hides the irony that disfigures him, by blowing his nose.

37. Luke's studio. Paris. Interior. (Day.)

Luke is writing again, with the euphemistic sweetness commended to him by Satan, as if everything had been lubricated by foresight and divine predestination:

'Now the apostles and the elders, in agreement with the other brothers, chose representatives – Judas called Barsabbas, and Silas – to send to Antioch with Paul and Barnabas, to carry a conciliatory letter ...' [Acts 15:22–23]

38. Clandestine meeting room. Interior. (Day.)

The four who are departing for Antioch – Paul, Barnabas, Judas, and Silas – are ready. It is the hour of goodbyes. James delivers to them the conciliatory letter, sealed.

One by one, then, Peter embraces them all and finally Paul for a long time (with true, complete sincerity?).

Then the four delegates leave the meeting room slowly, but with the pace of one who has a large goal to achieve.

39. Against the sky. Exterior. (Day.)

[Fading in, against a deep-blue sky, the marked face, sweet and elusive, of the author of Acts appears mysteriously, and lets these words fall on the spectator – abstractly and from afar, suddenly:

'With each institution diplomatic actions and euphemistic words are born.

'With each institution a pact with its own conscience is born.

'With each institution fear of the partner is born.
'The establishment of the Church was *only* a necessity.']
Devils.

49 A.D.

40. Geneva. Exterior. (Day.)

A slow panoramic shot of the station in Geneva and its large plaza in front (through which Paul and Barnabas passed the first time they arrived together in this city) makes us understand that we are in Antioch.

Paul and Barnabas are absorbed in prayer on the banks of the lake, close to the same place where the voice of God had chosen them for the first mission six years before.

Around them are many others: John called Mark, Silas, etc. There is also Luke, who from a certain moment onwards, will lower his eyes and will not look at what is happening anymore.

Suddenly Paul stops praying, and as if inspired, looks at Barnabas.

Paul:

'Let's get moving again and return to the cities where we first announced the gospel, and see how the brothers are doing ...'

Barnabas is immediately taken by his own inspiration.

'Yes, and let's also bring John called Mark with us ...'

'John called Mark? Don't you remember how he abandoned us in Pamphylia and left us without help?'

'What does it matter? He is a good brother.'

Others around them listen, embarrassed, frightened (Luke prays with his eyes cast down).

A sudden and overbearing fury now almost disfigures the inspired face of Paul, who bursts out in a loud voice:

'Then, let's separate from each other!'

Barnabas looks at him astonished and angry in turn.

Barnabas:

'And so, it's like that?'

'Yes, let us separate from each other! You go with John called Mark wherever you want. I will take Silas with me, and I will go to Syria and Cilicia.'

He gets up brusquely and, turning his back on Barnabas, departs.

Silas first, and then Luke (with his eyes downcast) follow him.

41. Piedmontese city. Exterior. (Day.)

'He came to Derbe, and then to Lystra …' (Acts 15:36–18:22)

A bus drives through the suburb of a provincial city, which is dusty and old but with its factories and its new, neocapitalist construction.

In a small plaza in the centre, the bus stops, and Paul and Silas – with the inspired pace of missionaries – get off the bus and are lost amid the small afternoon crowd.

42. Piedmontese city. Exterior – interior. (Day.)

In a quiet city street, a large public edifice rises, as if it were an old public building used for cultural functions, or the headquarters of the federation of a political party.

There is unusual activity in the street.

There are the guards, sleepy but attentive: and at the corner of a street, there is also a police jeep.

Add a scene which takes place in a Christian 'section' of the city. Paul controls the functioning of the organization (mimeographed pages, wall newspapers, leaflets) and most of all the account book (the offerings of rich, industrialist citizens, etc.).

Outline of a Screenplay 41

Inside this building, in a room packed with people, Paul is speaking:

'You know what commands we have delivered to you on behalf of Lord Jesus. Since this is the will of God, in which your sanctification consists: that you abstain from fornication; that each of you know how to use the instrument of your own body in sanctification and honour, not with voluptuous passion, as the pagans do, who do not know God; that no one sins against or deceives his own brother in these things since God is right to punish all these things, as we have already said to you and declared many times ...' [1 Thess. 4:2–6]

While Paul says these words, the public listening to him will be 'described'. In particular a young man will be described, around twenty years old, but serious, engrossed, somewhat gloomy, hollowed out by a youthful leanness full of nobility: the gravity of his expression could also be that of an adult man: but the naïve stress in his eyes reveals his youth.

Beside him, standing – and he holds her hand – is a girl, who resembles him a little bit, both in thinness and in naïve devotion to listening – perhaps his fiancée, perhaps his friend from school.

The eyes of Paul, speaking, settle on this young man and take notice of him.

'... Indeed God has not called us to impurity but to sanctification ... Therefore whoever scorns these precepts does not scorn a man, but God himself ...' [1 Thess. 4:8]

Perhaps the boy has realized that he is being observed by Paul, and looks at him, intimidated, upset, with still greater attention.

'Regarding then brotherly love you don't need me to tell you: you yourselves in fact are trained by God to love each other reciprocally. And as a matter of fact you already do this for all the brothers who are in the whole city ...' (1 Thess. 4:4–8, 4:9–12) [1 Thess. 4:9–10]

Speaking, Paul still observes the boy, even more confused and stiffened, who reciprocates Paul's gaze.

Internal dissolve.

Paul is continuing his discourse:

'Regarding then the apparition of the Lord, and our meeting with him, we beseech you, brothers, not to allow yourselves to be so soon shaken in your conviction or frightened, either by means of the spirit or the word ... as if the day of the Lord were imminent ...

'Let no one deceive you in any way. In fact, unless apostasy comes first and the Man of Sin, the son of perdition, is manifest, who opposes and rises above every so-called god and everyone who is believed to be the object of worship – so that he seats himself in the temple of God – wanting to show himself to be like God ... the day of the Lord will not be.

'Therefore you know what will slow that day, so that you can recognize him in his precise moment.

'The mystery of evil, in fact, already operates in these things.

'Only the one who restrains him now will be taken in the middle, and now the wicked will be manifest, which the Lord Jesus will kill with the spirit of his mouth and will annihilate with the splendour of his Apparition: the wicked – whose appearance is according to the virtue of Satan, with every power and with deceitful signs and wonders and with every seduction of evil by which they are lost, because they did not receive the love of truth that would have saved them. It is for this that God sends to them a transaction of deception, so that they believe in the lie, by which they come to be condemned, all those who did not believe in the truth but who delighted in evil.' [2 Thess. 2:3–12]

Paul in pronouncing these words is terrifying and almost livid – by who knows what mysterious engorgement of his spirit.

Internal dissolve.

Outline of a Screenplay 43

Paul's discourse is finished. But in that room, comments continue: many groups of people are talking here and there, etc.

Followed by Silas and the others who were closest to him, Paul approaches the young man who had observed him speaking – and who is still there, still mechanically holding his girlfriend by the hand.

Paul:

'Do you want to follow me?'

The boy answers right away, without thinking about it:

'Yes.'

'What is your name?'

'Timothy.'

'Who are your parents?'

'My father is Greek, my mother is Jewish, a convert ...'

'First I will circumcise you – even if it is in contradiction to my conviction – in deference to the Jews of this city, who know that you are of a Greek father.'

The boy looks at him, obediently. In Paul there is the arrogance of the leader.

Fade.

43. Lombardian city. Exterior – interior. (Day.)

Paul is now sleeping in a small room in an apartment in the centre of a city (perhaps previously shown from a bird's-eye view or in its entirety from above: this corresponds to the city of Troy).

Paul is ill: he is agitated in his sleep, and moans. His illness torments him, etc. There to wake him is Timothy, the new disciple who at this point has followed him for a short time and is his favourite.

Paul's moans last a long time, and he sometimes awakens and asks for something to drink, etc.

Finally he seems to doze off, a little relieved.

Timothy struggles with sleep, until, eventually, it wins.

Dawn breaks. Its first white light enters the squalid room.

But now Paul is, with his eyes open, fixed upon a vision.

Before him there is a young man: blond, tall, strong, beautiful, with clear, sensual, and pure eyes.

He looks Paul in the eyes, filled with some kind of hope and at the same time with much sadness.

And Paul looks at him in silence.

Until the young man begins to speak:

'Come to Macedonia to help us!' (Acts 16:9)

Paul looks at him in wonder. But under the gaze of Paul, slowly, he is transformed. This strong, blond young man – as if something external to him is physically representing the interiority and the truth – becomes ever more pale, exhausted, devoured by a mysterious sickness: little by little he is half-naked, horribly thin; he falls to the ground, curled up into a ball; he becomes one of the dreadful living corpses of the concentration camp, with shaved head, bluish skin, awful smiling eyes, swollen in the face reduced to a few small bones, like that of a child, the little flesh horribly disfigured by repugnant sores and purulence.

44. German countryside. Exterior. (Day.)

In a train loaded with emigrants and poor people, Paul and his disciples (Timothy, Silas and the author of the Acts of the Apostles, Luke, previously possessed by the Devil) travel through the wide German plains – the villages with their sugar-loaf roofs, etc. – the infinite expanses of the industrial peripheries of the cities, etc. (Acts 16:9)

(The compartment of the train can be filmed in Italy, with fifty or so extras: the 'visions' beyond the window, of agricultural and industrial Germany, can be shot separately.)

45. The Station at Monaco or Colonia. Exterior. (Day.)

Paul and his disciples, lost in the crowd at the station of a grand German city – and then in the traffic of the large plaza in front of the station.

American soldiers can be seen.

German police officers can also be seen: very similar, as ever, to the SS, with their cult of authority and order (mixed with a kind of mysticism and chastity that render those hateful faces almost beautiful).

Our people are lost in the immense crowd, in traffic – among men who at all times think of things other than religion. Some police officers join them. They ask them for their documents.

For the second time the images are accompanied by a musical soundtrack: this time, however, it involves sacred music.

46. Prison in Monaco or Colonia. Exterior. (Day.)

The circle is closed tightly – the will for order accomplished.

The eye of the police, quickly focused on these *irregulars*, has caused contemplation to be followed quickly by action.

Paul and his people get out of a paddy wagon that has stopped at the door of a prison, and they cross through this sad door, between the guards, followed by an indifferent escort of mystical and pure hounds of authority.

(To be filmed in a real place in Germany – twenty or so extras.)

47. Office of the prison in Monaco or Colonia. Interior. (Day.)

The prisoners come to be introduced to the office of a commissioner (or some sort of generic authority, but regardless, with a

hateful, governmental, servile face, with pathological and repellent characteristics of the ignorant petit bourgeoisie, etc.).

He interrogates them brusquely, disassociating himself from them (as already the *capos* of the concentration camps disassociated themselves from those whose life 'was not worthy of being lived').

'Who are you? What did you come here to do? Etc., etc.'

Paul and his disciples do not answer, proud and resigned to the worst, etc.

A guard approaches them gently, and a first punch comes most violently, unforeseeable, blinding, like the attack of a viper: struck, Paul falls to the ground, writhing with a bleeding mouth.

The slow police thrashing begins – which is not useful to describe here.

(This scene can be filmed in the studio.)

48. Prison in Monaco or Colonia. Interior. (Day and night.)

Obviously absurd (cf. words of the writer of Acts, scene 24), the cells of the prison in Monaco or Colonia (which can be reconstructed in the studio) are like the cells of the prison in Philippi: and the prisoners are bound by chains fixed to the wall.

It is night. Paul suffers horribly from his illness, which covers him with sores and swellings (so much so as to render him like the 'monster' of the concentration camp into which the young German man who had called on him in Germany was transformed in the dream).

Nevertheless, although tormented, he becomes strong, gets up, and begins to sing: Silas is made courageous by this and begins to sing the sacred song with him.

The other prisoners are listening to them. By chance a violent earthquake shakes the foundation of the prison: the doors are

opened by themselves and the chains, unfixed from the walls, shaken, dissolve. Roused from sleep, the jailer see the doors thrown open; and, thinking that the prisoners have escaped, pulls his pistol from its holster, ready to kill himself, out of fear of punishment. Paul shouts:

'Don't harm yourself, we have not escaped.' (Acts 16:19–32)

The prison guard, trembling, enters the cell with the light, and falls at the feet of Paul and Silas.

'Tell me what I have to do to be saved.'

Paul looks at him with a gaze that scrutinizes him to the core, searching his conscience, reading it all, even that which he himself did not know. And finally divining the true reality, and so being able thus to interrogate or reveal, the prison guard begins, as if outside himself, by inspiration, the following discourse:

'What can I do to be saved?

'You have inspired me: with you, I know what I never knew, because your gaze is not in me nor in the world. I am confused about myself and the world. I believed that my duty was here. But the power that I have served hasn't only one modality: to exclude, to segregate, to martyr and to assassinate those whose life it does not consider worthy of being lived. It also has a second mode, which is that which made of me its servant. Just so my life became worthy of being lived in front of power: but by now it is no longer worthy of being lived in front of my conscience. Of so many crimes I have been complicit, through a hate which I *really* proved through servility toward my bosses, without taking account for myself how the bosses rendered me the object of the *same kind of hate*, before those who instead are my brothers.'

Paul – wounded and disfigured by the illness that he has contracted, has the strength to pronounce with conviction and gentleness:

'You believe in Lord Jesus, and you will be saved, you and those in your house.'

Having said these words Paul faints and falls. Lost in his blackout he begins to be delirious: he must suffer terribly because of some nightmare. And in fact he mutters to himself confused words, among which are 'Father', 'Mother', agitated by a terrible mania which makes all his limbs shake.

49. Dream of Paul. Tarsus. Various settings.

Paul dreams fragments of his infancy.

His birth.

His feeding.

His father who one day in the garden lifts him toward heaven.

A trip from school (which we have seen in his sojourn in Tarsus). With some companions he wanders around the city and arrives in an enchanted rural place (which we have seen appear to him during the abduction to the Third Heaven).

Finally he arrives with his companions at the stadium. Some bigger boys run races. Then in the locker room they undress completely before the eyes of the younger boys and Paul.

Upon returning home, Paul feels ill. He is taken by convulsions. The same ones that will persecute him all his life.

50. Prison in Monaco or Colonia. Interior. (Day.)

In the cell it becomes day.

The converted jailer arrives, with a happy air, and announces:

'The magistrates have let you be free, you can go!'

Paul is liberated from an attack of his illness.

His face is normal. His expression is hard, certain, almost authoritarian. (It seems that the old Pharisee, born in normativity, in legality and in privilege, speaks now in him, rendering him unrecognizable, compared to the wounded Paul who had sung the sacred song through the night.)

He speaks decisively, strongly:

'They beat us publicly and without a proper trial; they threw two free citizens into jail, and now they would like to chase us away secretly? Let them come liberate us in person.'

Dissolve on his secure and furious face.

51. Bonn. Exterior – interior. (Day.)

From a general view of the city (Philippi), we pass to the interior of a vast office: it is the 'Christian section' of Bonn. Mimeographed pages, newspapers, manifestos. There is even a small print shop. Paul visits everything with the aspect and attitude of a minister, a leader.

Then, followed by the most important collaborators, he goes out and gets into a big Mercedes.

The route of the Mercedes shows us a rich neighbourhood in the capital. Meanwhile the car stops in front of a particularly luxurious house, in a residential zone of the grand bourgeoisie: it is the house of Jason.

52. Jason's house in Bonn. Interior. (Day.)

The interior of Jason's house corresponds to the exterior. A refined house of the grand bourgeoisie, immense, furnished in a refined fashion, etc., the centre of social gatherings as well as perhaps literary ones (in fact intellectuals are among the invited guests).

A cocktail party rages: elegantly dressed ladies, servants, crystal glasses, chairs, parlour corners, etc., etc. Social smiles belonging to 'spiritual' ladies ('and also distinguished ladies, highly placed, and notable Greek men' (Acts 17:4–15)).

All of the invited guests are about to listen to Paul (just as in a modern drawing room one gets ready to hear, let us say, Krishnamurti, guest of some 'highly placed' lady). Putting down

their glasses, etc., they gather in an even larger salon, where the 'sainted' Paul comes to be introduced, with much esteem, and a shiver of scandal and expectation. He is still hard, secure, 'Pharisaic', as in the last scene in the prison.

The audience is quiet, and Paul begins to speak:

'Behold, for me to live is Christ, and to die is gain.

'Therefore, if it is to live in the flesh that gives me the occasion for the fruit of labour, what thing to choose? I don't know.

'And yet I am pressed in between these two things: on the one hand, the desire to be freed from my body and to be with Christ, and this would be better; on the other hand, to remain in the flesh is more necessary for you.

'Well convinced of this, I know that I will survive and remain for you all, for your advancement and the joy of your faith – so that in my care your merit grows always more in Christ because of my presence among you …' [Phil 1:21–5]

The people in the salon listen to him with reverence, but it is a preconstituted reverence: just as their comprehension is a priori. At root, they are disinterested in the 'reality' of which Paul speaks: for them, in a certain sense, as far as he is concerned, the sound of his voice alone is enough, and as far as they are concerned, their attention is enough: which implies a sort of faithfulness to the media, which wants you to be religious, that is, confessional.

Internal dissolve.

Paul continues his speech.

'So, my beloved, obedient as you have always been, with fear and trembling you work for your salvation. God in fact is the one who works in you the desire and the action according to his approval.

'Do everything without grumblings or contestations, so as to be irreproachable and pure, "children of God without blemish" in the midst of a "wayward and perverse generation", in which you

Outline of a Screenplay

ought to shine as stars in the world, carrying high the word of life: and this will be for me a cause for pride for the day of Christ, that I have not run the course in vain, nor in vain exhausted myself. But even if I ought to be poured as a libation on the sacrifice and offering of your faith, I am happy about it and rejoice in it together with all of you. Likewise even you should be happy and rejoice with me ...' [Phil. 2:12–18]

At the back of the room there are – as we have said – attending out of curiosity, some intellectuals, old and young. They are not unpleasant. Rather, they represent the light of intelligence in this rich, elegant place that is, at root, culturally in bad taste.

They listen, with a 'secular' detachment, to what Paul says, but they are by formation, education, nature, absolutely far from him. The criticism that they mobilize can even be acceptable.

'Yours is a true longing for death.'

'A thanatophilia, clinically ascertainable ...'

'To which will be placed in relation to another mania: that of seeing everything in terms of relationship between the mother and child, between the father and child. I heard him by chance in Lystra, in Cilicia: "I feel very tender among you, like a mother who feeds and warms her children at her breast."' [1 Thess. 2:7]

'In short, paternalistic and ... maternalistic at the same time! So, authority arrives at the heart of the child as much through the father as through the mother (this second case is the more insidious). He does not conceive anything outside of this exchange of roles between parents and children, in giving the benefits of authority.'

'There is a continued identification with his father and his mother (two rich bourgeois of Tarsus, it seems, with all the necessary requirements). He cannot but treat us, therefore, as his children, being tender in the manner of a mother, reproving in the manner of a father.'

'From this comes the fact that he considers himself indispensable.'

'His mother will have habituated him to this, given that certainly he was a model baby, eternally rewarded.'

'It's a case of narcissism pure and simple.'

'But from Jung's side, given his apocalyptic desire to die, it seems to me more collective than personal.'

'Who knows for what he wants to be punished, this priest, with his longing for death.'

(While in close-up these comments resound, in the background the voice of Paul continues to be heard, speaking the connecting passages from the letter to the Philippians, from which this discourse is taken.)

Internal dissolve.

Paul continues to speak:

'Brothers, in competition become my imitators and observe those who walk according to the model that you have in us. Many in fact walk as enemies of the Cross of Christ ... and I tell you this weeping: their end is perdition, their God is their belly, their glory consists in shame, they want earthly things ...' [Phil. 3:17–19]

The intellectuals, in a corner, continue to spill, ironically but not hatefully, their observations into each other's ears:

'The German soldier who appeared to him in a dream, and had him come here, had he made an exact portrait of neocapitalist Germany?'

'It seems in fact that his allusions are clear.'

'But what does he oppose to well-being? An old humanistic spiritualism? A reified Church?'

'Yeah, what could he do differently? What other answers could he give to our practical questions, if not holy answers?'

And Paul:

'Be always happy in the Lord. I repeat it to you again: be happy! Your amiability is noted among all men: the Lord in fact is close.

Outline of a Screenplay

Don't worry yourselves about anything; rather in every thing let your questions be made known to God through prayers and supplications – and then offer him thanks ...' [Phil. 4:4–6]

53. Jason's house in Bonn. Exterior. (Day.)

In front of Jason's house, in the immaculate residential neighbourhood, a rowdy crowd has gathered: it is what is called a 'fascist brawl'. There are in fact young faces of thugs and old faces of incorrigible Nazis, refugees from the purge, or those returned to the surface after a deserved season out in the cold.

They whistle, intoning old dirty songs. There are also – indifferent observers – some American soldiers.

The throwing of some rocks begins, and the whistles and shouts become more violent. Police sirens are heard.

(This scene to be shot in Bonn: around two hundred extras.)

54. Jason's house in Bonn. Interior – exterior. (Day.)

Paul continues to talk (Letter to the Philippians 4:8–10), while outside, the uproar becomes still stronger. The people who are present are frightened, and they don't listen to him anymore.

A glass window goes to pieces, owing to a blow from a stone, with a shattering noise.

Those present are moved to panic.

The owner of the house runs toward Paul and his disciples, and pushing them, makes them leave by a service door.

Crossing the servants' area, they arrive at a small door which opens onto the back part of the garden, and from there to a door that leads to a small street behind the house. Two or three cars are ready.

Paul:

'It's good if we separate ...'

Thus Paul and his companions hurriedly get into two different cars that leave right away, while the shouts of the fascists and the police sirens are still heard, in the distance.

(This scene will also be shot in a real villa in Bonn.)

55. Jason's house in Bonn. Interior. (Day.)

While the tumult still continues, a radio commentator, with his helpers and his recorder, tries, with the satisfied air of someone 'making a shot', to get close to some of the intellectuals who were present at Paul's speech.

[(Radio interview about Paul: What will prevail, among other things, is a response that situates Paul in the historical–cultural frame of his time, with precision and accuracy drawn from German philology. The contributions of Hellenism, of the Stoics, of specialists in holy scripture, of mystery religions, etc., and the subsequent linguistic and theological contaminations of Paul's theories by those of his time: what will be emphasized/ highlighted in this interview above all is Christian syncretism; and thus Christianity as a historical product of the whole Jewish-Greco-Roman world, and which only accidentally finds in Paul its theory, etc., etc.)]

Replace this theoretical discourse with a frame of the organization created by Paul: sections, membership, funding, capital, banking.

56. The suburb of a big city: Rome. Exterior. (Day.)

A sun that renders everyone equally anonymous, tragic, and quotidian burns onto the heads of Paul and his few, poor listeners.

There is a small group of people from the outskirts, rendered black by the large sun, bruised and sweet; the listeners will

Outline of a Screenplay

probably, in fact, have exited from the colourless, pockmarked, and immense apartment blocks that puncture the horizon.

Here there is a border of stunted grass; a bridge; a garbage heap; a desolate excavation.

Paul speaks almost to himself or to the light of that sun.

Bathed in sweat, taut, white from the physical pain that consumes him – his is like a delirium. He improvises, as a poet can improvise.

(This is the only scene that is 'abstracted' from the story of the life of Paul: chronologically it could be inserted in whatever place in the story, even if it is based on a passage from Acts 14:14–20 – and the words are taken from the first letter to the Corinthians, *passim*).

Paul, suffering and almost delirious, speaks as if detached and to no one:

'Someone will ask me: how are the dead resurrected? With what body will they present themselves? Oh, what a stupid question!

'That which is sown does not return to life without first dying.

'And if you sow, it is not the body that will be that is sown: but a simple grain, for example, of wheat or some other thing. God then gives it a body which he has established: to each seed he gives its own body.

'Not every flesh is the same flesh; but one flesh is that of men, one flesh is that of animals, one flesh is that of birds and one flesh is that of fish.

'And there are celestial bodies and terrestrial bodies: but the glory of the celestial bodies is different, that of terrestrial bodies is different ...

'There is one radiance of the sun, there is one radiance of the moon and one radiance of the stars: one star is in fact different from another star with respect to radiance.

'The resurrection of bodies is also like this.

'It is sown in corruption: and what is sown in corruption rises again in incorruptibility. It is sown in shame, and what is sown in shame rises again in glory. That which is sown in weakness rises in power. An animal body is sown, a spiritual body rises again.

'If there is an animal body, there is also a spiritual one.

..........

'But I say to you, brothers, that flesh and blood will not be able to make the Kingdom of God their own, nor can corruption make incorruptibility its own.

'Behold that I announce to you a mystery: all of us, certainly, will not fall asleep, dying, but all will be transformed in an instant, at the sound of the final trumpet ...

.........

'It is necessary in fact that our corruptible being be clothed in incorruptibility, and that our mortal being be clothed in immortality. When everything is completed, the word will be fulfilled as it was written: "Where, death, is your victory? Where, death, is your sting?"

'The sting of death is sin; and the power of sin is the Law.' [1 Cor. 15:35–44, 50–2, 53–6]

Even as he speaks, deliriously, a police jeep approaches and later on stops at the corner of the street, scorched by the sun.

Then, the few miserable people who had come to hear Paul with some sort of hope in their hearts are mixed together among some young men with dark and fierce faces.

And then suddenly a gang arrives in a truck: they are 'thugs' and among them, less visible, is the distorted face of the man from a fanatical group, who leads them.

The action is swift, as in a dream. Everything happens quickly as lightning under the heedless eyes of the police: the assault of the thugs amidst the shouts of mockery and anger; the flight of the poor people; the thrashing of Paul and his two or three anonymous disciples who are close to him.

A cold and macabre beating, detached from every human feeling.

Then, the aggressors, as quickly as they had come, get into their truck: but not without one of them, before departing, spitting on the inanimate body of Paul.

In the blinding sun, Paul seems to be dead: his body is not moving.

Seen in close-up is a mask of blood: clots of blood and dust – unbearable to the eyes and unrecognizable.

57. Rome. Exterior. (Day.)

Some 'Epicureans and Stoics' are seated at tables at Caffè Rosati on the Via Veneto. (Rome is, by analogy, Athens.) They argue among themselves ironically and with great energy, drinking coffee.

'Who is this new guy who goes around Athens, do you know anything?'

'He's someone from Tarsus. A Pharisee.'

'But *civis romanus*.'

'Yes, he operates fully in the spirit of the Atlantic Pact.'

'And what does he say? What does he say?'

'Well, he talks about a certain Jesus and his resurrection!'

'My Jesus!'

Other intellectuals are seated at the Caffè Rosati in the Piazza del Popolo. Even there the question is debated, but with much calm and detachment and with all deserved scepticism.

'What does this windbag mean?'

'It seems that he announces foreign divinities …'

'And yet it would be interesting to hear him … Let's organize a debate, a press conference, one of these things …' (The one who speaks, one doesn't know why, is almost angry, perhaps with himself, perhaps with the chronic lack of organization among the … Athenians. On the other hand, he speaks with a southern accent.)

'To the Areopagus?'
'To the Areopagus!'

58. Press room or bookstore in Rome. Interior. (Day.)

A large crowd of intellectuals is gathered in a large, modern, neocapitalist room (we place it at EUR [*Esposizione Universale Roma*]) — at least it isn't one of those old frescoed rooms of the eighteenth century, in the headquarters of the journalists' union, etc.

There are photographs, etc. Paul is alone at the speakers' table (Timothy and Silas have remained in Berea, Acts 17:16–22).

Next to Paul is seated a 'moderator' (with the face of a Roman intellectual, also of southern origin). He speaks, democratically and uncertainly:

'So, who wants to intervene …'

The audience, embarrassed, hesitates a little. Then one (another Roman intellectual, in a double-breasted suit) raises his hand and, with a southern accent, says with little confidence in the 'magnitude' of the thing:

'Can we know with greater precision the news that you are announcing? The words that you say are rather curious: we would like to know what they mean …'

('In truth, the Athenians and the foreigners who lived in the city, idlers by vocation, were always on the hunt for novelty.' Acts 17:16–22)

Now Paul — with the hard and secure face of a decent man and of high social extraction — he, also, in a double-breasted suit — begins the speech that he prepared accurately according to the rules of rhetoric. Thus, contrary to his usual practice, he reads:

'Athenians, I see that you are, in every respect, the most religious men in the world. Travelling through your city and observing

Outline of a Screenplay

your sacred monuments and sanctuaries and altars, one in particular attracted my attention, for its inscription: to an unknown God. I am here to announce to you that which you honour, without knowing it. The God who created the world and everything that it contains, Lord of heaven and earth, does not inhabit temples built by man, and cannot be served by the hand of man, as if he had need of our thing, he who gives life, breath, and every good to everyone.

'It is he who caused the whole of humanity to descend from a single man to populate the earth, fixing the ends of their life in time and space, inviting them to grope for him, in order to find him, to come close to him, while not being far from any one of us. In fact, *in him we live, are moved and*, as one of your poets has put it in verse, ... *are of his family* ... If therefore we are of the family of God, we ought not believe that God is like a statue of gold or silver or stone, the work of human industry and intelligence. Now God, closing an eye on past times, the times of unconsciousness, makes known to the men of the whole earth the good news of repentance. He has fixed the day on which *he will judge the world according to righteousness*, by means of one chosen by him and rendered by him trustworthy in everyone's eyes, resurrecting him from death ...' [Acts 17:22–31]

Hearing him actually speak of the resurrection and of death, the audience of Roman intellectuals begins to get bored, and their faces assume that well-known ironical expression.

Indeed, one consults his watch, gets up, bored and in haste moves along the row of seats, not without first having spilled into the ear of his friend:

'We will listen to this another time ...'

59. Streets of Rome. Exterior. (Day.)

Alone, Paul wanders through the streets of Rome. In a gentle and cruel light. Where everyday life, even in its normalcy and cheerfulness, seems like a nightmare.

Always alone like a dog, Paul approaches certain gardens, too green, too sunny – everyone is anonymous. Soldiers, far away, pass by, etc.

Paul is taken by his illness, which gives him terrible pains.

He goes near a sapling, bends over, and vomits.

His face is full of tears. He goes to a fountain to wash his face. Then staggering, he goes to a bench and relaxes there, like a beggar, his face ashen and wet: he falls asleep, perhaps, and it is as if he had fainted.

60. Rome. Television studios. Interior. (Day.)

Many of the intellectuals who were in the room where Paul's unhappy press conference took place swarm through the squalid corridors of the television station.

Witty, they chatter among themselves, in a good mood: only pretending to be a little bored by the task that awaits them.

One of them is in the squalid and bare make-up room, and smiles at four or five colleagues who have just arrived, etc.

Then from there into the room – which is also empty and squalid – where the 'crew' is ready to 'film' the interview.

Internal dissolve.

(Interview with Paul: with interventions by historians, secularists, Marxists, clerics, etc. – a psychological interpretation prevails, which sees 'redemption' as a 'return' to the infantile state, in which the newborn, on the one hand, is happy, because he is at the *mercy* of his Parents, and on the other feels 'guilty' for the sole fact of being: he is deprived of 'reason'; he lives only by 'desire' and

therefore 'practicality'; but his desire counts for nothing without the intervention of his Parents, whose life is 'separated' from his like the light from the shadow; so their 'grace' coincides with their 'transcendence', that is, with their pre-existence in the absolute and prenatal light.)

61. Geneva. Station. Exterior. (Day.)

Paul is awaiting the arrival of a train that brings his young friends and disciples Timothy and Silas to Geneva (Corinth).

Here is the train that arrives from the north, and here are the two young men with their tattered baggage. Moved, they embrace Paul, who is also moved: he is visibly tormented by his illness.

Then they move away along the shelter, and behind them, from afar, one hears the voice of one of the two young men, speaking of practical things, as follows:

'We are informed that here in Corinth you are the guest of a Jew of the name of Aquila and his wife Priscilla ...'

'Yes, he is the manager of a textile factory ... I labour in the factory as a worker ...'

'We know that you know the trade, because even in this, your far-sighted parents have prepared you ...'

They disappear into the back, along the shelter full of poor people.

(This scene will be filmed from real life.)

62. House of Aquila and Priscilla in Geneva. Interior. (Day.)

The home of Aquila and Priscilla is a luxurious penthouse in the elevated part of the city: from there you can see the whole expanse of the gulf.

A bit like in the house in Bonn – the traditions of taste change, the familial habits, etc. – Paul is preaching to enlightened, intellectual 'Gentiles', highborn ladies, rich and spiritual bourgeois, etc., who listen to him with reverence. Only the intellectuals – like those in Bonn – who are of Crocean training and therefore doggedly secular and historicist – or who are Marxist – listen with sympathy to his speeches, but are absolutely disunited with him on the terrain of religion.

They have kind and intelligent faces: and one tends to agree with them when they then comment on and critique Paul.

Paul speaks with inspiration, but healthy, hard, strong, self-assured, paternal albeit with maternal tenderness, authoritatively.

He is making one of the most sublime speeches of his preaching:

'Since in the wisdom of God the world didn't know God by means of wisdom, it seemed good to save the believers by means of the foolishness of this preaching! And in fact, I – while the Jews claim signs and the Greeks claim wisdom – I preach Christ crucified: scandal for the Jews, foolishness for the Gentiles.' (1 Cor. 1:21–3)

Internal dissolve.

'God chose foolish things of the world in order to confuse the wise, and the weak things of the world God has chosen in order to confuse the strong; and the things of humble origin in this world and those despicable things, God has chosen – precisely what does not exist, in order to reduce to nothing what does exist, in this way no human reason can boast before God ...' [1 Cor. 1:27–9]

Internal dissolve.

All the listeners are enchanted before these words. Even the intellectuals, at the back of the room, are overpowered by them – almost detached from themselves, from their 'human reason'.

And Paul continues:

Outline of a Screenplay

'Even I, brothers, coming close to you, did not come with excellence of speech or wisdom to announce to you the testimony of God!

'In fact I didn't ever consider knowing anything, in your midst, except Jesus Christ and his crucifixion. Rather, I came here among you, full of weakness, fear and trembling: and my speech and my preaching did not wish to consist in persuasive discourses of wisdom, but in the demonstration of the Spirit and of power: so that your faith not be founded on the wisdom of men but on the power of God ...' [1 Cor. 2:1–4]

At these last words – the intellectuals, or the educated people – who held themselves at a distance, in the back of the room, beside a large window facing out on a terrace, which itself faces out to sea – begin to relax and sort of free themselves from the spell of Paul's first words. One of them looks out the window: one suggestive of the city lost in its traffic, and of the sea lost in its silence.

Paul continues:

'Among those who are at the level of understanding, it is true that I also spoke about *wisdom*, but it doesn't concern a wisdom of this world – nor the privileged of this world, destined nevertheless for destruction – but I spoke about the *wisdom of God*, shrouded in mystery, which was hidden, which God predestined from the beginning of the ages, for our exaltation, and which none of the privileged of history have ever known ...

'To us God has revealed this mystery by means of the Spirit, because the Spirit scrutinizes everything, *even the profundity of God*.

'In fact, what man ever knows the secrets of man, except the human spirit which he has in him? In the same way, no one knows the secrets of God, except the same Spirit of God.' [1 Cor. 2:6–7, 10–11]

The attention – albeit objective, for these 'irrational' but profoundly fascinating enunciations – is rekindled.

'Now, we are not interested in possessing the Spirit of history, but the Spirit of God, in order to be able to know things that are given to us only by the grace of God.

'And we do not speak of these things with speeches taught by *reason*, but those taught by the *Spirit*: it is in this way that there is a perfect correspondence between the spiritual man and spiritual things. The rational man, by contrast, does not accept the things of the Spirit of God, because for him they are madness – and he cannot know them, given that a discrimination operates between them and the spirit: without understanding, rather, that the one who is spiritual discriminates everything, while he is not discriminated by anyone!' [1 Cor. 2:12–15 ... with interesting changes]

Internal dissolve.

'Do you not know that you are the temple of God and that therefore the Spirit of God lives in you?

'If anyone profanes the temple of God, God will destroy him, because the temple of God is sacred, and you are the temple of God.

'Do not deceive yourselves: if anyone of you believes himself to be wise in this world, *let him become foolish in order to become wise!*

'Because the wisdom of this world is foolishness before God.' [1 Cor. 3:16–18]

Internal dissolve.

(Now the speech has changed register, turning to other topics.)

' "Everything is lawful to me", but not everything is advantageous; "everything is lawful to me", but I will never be confined under the power of anyone. "Foods are for the stomach, and the stomach is for foods", but God will destroy both one thing and the other.

'The body then is not for fornication, but for the Lord: and the Lord is for the body ...

'Do you not know that your bodies are members of Christ? Ought you to take the members of Christ and make them members

of a prostitute? It is intolerable! Do you not know that the one who is joined to the prostitute forms a single body with her – as the sacred texts say: "The two will become one flesh"? On the contrary, the one who is joined to the Lord is with him *one spirit*.

'Avoid fornication! Every sin that a man can commit excludes his own body: the fornicator, however, sins in his own body. And your body is the temple of the Holy Spirit – that blows from God – so much that you are no longer your own. God has thus reacquired you, you are his: and you ought to exalt him even in your body!' [1 Cor. 6:12–20]

The audience is still attentive: the signs of boredom and a certain irony begin to show only in the faces of the intellectuals. However, Paul's face is not as inspired as it was in the beginning of the speech: something dark, violent, and perhaps disturbed is in him:

'Do not deceive yourselves! Neither fornicators, nor idolaters, nor adulterers, nor the effeminate, nor the perverted, nor thieves, nor drunkards, nor detractors nor the greedy will enjoy the fruits of the reign of God!' [1 Cor. 6:9–10]

Paul continues to speak in this tone (1 Cor. 6:7–11; 7:2–5) while we hear in the foreground comments from the intellectuals (generically defined):

'Here we go with the moralism. It is true that practice, pressed to its limits until it becomes pure pragmatism, is religious: but it is also true that religion, the most metaphysical and irrational, always ends up by becoming practical: "a code of conduct!" '

'You wonder why? The one who speaks is one who doesn't conceive of anything outside the code – of the Law! He barely abjured one Law when he immediately institutes another: thereby being the biggest damned nuisance to people.'

'Necessarily, he is an ex-Pharisee, coming from a traditionalist Pharisaic family, not to say reactionary. He was a collaborationist in wartime, understand. Nothing but a nasty, hateful person!'

'He doesn't do anything but talk of prophecies, of people of prophetic spirit – and then all this moralism! And he did so with innocence. No, he is blackmailing, menacing, apocalyptic …'

'There's something wrong inside him: something horrible. He killed prisoners, when he was a Nazi. Things like this are not erased from a life, they are a part of it. And in fact, a fanatic continues to be fanatical. His moralism is atrocious …'

'He is a Pharisee … as I had to tell you!'

'He doesn't do anything but talk about ecclesiastical and liturgical problems, of animals strangled or not, of baptisms … and of circumcisions, those damned circumcisions … It is true that they are the practical aspect of a much larger problem: the relations between Jews and Gentiles, between the Elect and the non-Elect, and everything depends on it from there to be affirmed by his doctrine. But how does a man like him occupy himself with such nonsense …'

'He is especially a great organizer …'

'And on what does he found his organization? On a legalistic and maniacally conformist spirit, puffed up like a miasma from who knows what filthy depth of his unconscious. And, alas, this legalism and personal conformism coincide then with that national Jewish conformism …'

And Paul, undaunted:

'Concerning then the questions that you put to me, it is better for a man not to touch a woman. But because of fornication, each man should have his own wife, and each woman should have her own husband. The husband then renders to the wife what is necessary, and just so the wife to the husband.

'The wife does not have rights over her own body, but the husband does – and vice versa. Do not remove yourselves one from the other except by agreement and for a short time, in order to attend freely to prayer – and be back together, so that Satan does not tempt you by means of your incontinence.

Outline of a Screenplay 67

'But this I do not say to you as a compromise, but as an order: *I want in fact that every man be as I am* – but everyone has his own gift from God, one of one kind, the other of another.

'To the unmarried, then, and to the widows, I say, *"it is well for them to remain as I am ..."* '

During this part of the speech, after having exchanged a look of intelligence and a gesture, the 'intellectuals' leave the room slowly – as if for a well-educated and discreet protest, or with a patient irony in their eyes – through the large glass door, they go out onto the terrace. Paul's voice continues relentlessly (1 Cor. 7:5–11ff.).

63. Terrace of the house of Aquila and Priscilla in Geneva. Exterior. (Day.)

The intellectuals – pathetic, rationalist, quotidian – flow around the terrace ... and breathe, facing the large blue sea ...

'Ah, a little air ...'

'I've never seen a more irrational radical: a true terror.'

'He has put back into circulation *the pure infantile state*, drawing upon the most disparate ideological and linguistic materials – the Old Testament, Hellenism (arriving through the lineage up until Plato), mystery religions, but especially the Gnostics, thus creating a language of argumentation at once eclectic and ironclad. No poet has ever succeeded in a similar project. The memories of infancy make everyone laugh.'

'Yes, however, out of this pure and frightful irrationalism, he creates a law and establishes a Church. He is, more importantly, a big organizer. Half the world is now populated by his organizing centres. He doesn't miss a beat. He is an extremely practical man, a bureaucrat, a general.'

'Shhhhh ...'

Paul's voice is in fact heard resounding from beyond the wall

and the glass door. Framing this arid portion of wall and glass, we hear the 'clerical' voice of Paul:

'But I want you to know that Christ is the head of each man, while man is the head of the woman, and the head of Christ is God.

'Each man who prays or prophesies, having something on his head, dishonours his own head.

'On the contrary, each woman who prays or prophesies with her head uncovered dishonours her own head because this is the same as if she were shaved. In fact, if a woman does not want to put on a veil, have her hair cut!' [1 Cor. 11]

The intellectuals are dismayed:

'He's dreadful!'

'Shhhh, shhhhh!'

Beyond the walls of the terrace, Paul's voice resounds, monotonous and stubborn:

'As in all the Churches of the elect, let the women be silent in the assembly, since it is not permitted to them to speak: let them obey, instead, as even the Law says.

'If they want to learn something, let them ask their own husbands at home, since it is improper for a woman to speak in the assembly ...' [1 Cor. 14]

'Irrationalism is terror, and it is terror, these stupid and atrocious rules.'

'Theology and practice are confused in an absolutism that is humanly unsustainable, so that in everyday life there remains a big void and this big void is filled up by rituals and norms. Some good result!'

'And everywhere the *guilt*: the guilt, simply, of being born, of existing.'

But while the intellectuals say these things (or analogous things), Paul's voice rises. It has a new resolve. A new register.

'I say again: let none of you consider me a fool.

Outline of a Screenplay

'Or if you do, accept me as a fool, so that I am able to boast a little! But what I say, I do not say according to the Lord, but as a fit of madness – given that many boast in the context of physical life and in the context of reason, and so I want to boast a little myself ...

'In fact you, who are wise, willingly support the words of fools!' [2 Cor. 11:16–18]

The intellectuals listen, once again fascinated, detached from themselves.

And Paul:

'If therefore it is really necessary to be proud of something, then I will be proud of my weakness ...

'I have to be able to be proud of something! But this is not convenient ... In spite of this, I will see visions and revelations of the Lord. I know a man in Christ, who, fourteen years ago ...' [2 Cor. 12:1–2]

One of the intellectuals approaches the window through which the words come, and from behind the backs and necks of the silent bystanders, he observes Paul – pale, bathed in sweat, almost at the point of fainting: he continues, suffering and inspired to speak:

'... whether in the body I don't know, whether out of the body I don't know, God knows – was taken up to the Third Heaven. And I know that this man – whether with the body or without the body I don't know, God knows – was taken into paradise and heard inexpressible words, which it is not permitted for anyone to utter. On his behalf, I will be proud. On my own behalf, however, I will not be proud of anything but my weakness. If in fact, I will be proud of myself, in this case, I will not be foolish because I will speak the truth. But I prefer not to do it ...

'So that I might not become proud, a pain in my flesh was given to me, a messenger of Evil was sent to me to degrade me – so that I would not be proud! And so many times I prayed to the

Lord to spare me this pain and this degradation! But he answered me: "My grace is enough for you: in fact power is perfected in weakness."

'So, I will be proud only in my weaknesses, so that in me there is nothing but the power of Christ. For this I am content in weaknesses, in injuries, in needs, in persecution and in misery. In fact, when I am weak, then I am strong.' [2 Cor. 12:1–10]

Now Paul is alone on the terrace and he looks before him: the city that slopes toward the sea, the port, the sea. His gaze rests on the sea, which appears like an immense blue wall, lost against the horizon. Silent, enigmatic, insurmountable.

With his eyes full of this vision, Paul re-enters the house and goes through a very small glass door into a room that, obviously, the masters of the house have dedicated to his organization. Many of Paul's collaborators are at work, before typewriters. A group is discussing the draft of a manifesto.

Paul sits down at a writing desk and begins, inspired and tense, to write:

'Paul, servant of Jesus Christ, to those in Rome who are beloved by God, our Father and Lord Jesus Christ ...'

And through the window the immense blue mass of the sea can be glimpsed, lost in the blue horizon.

It is this ultimate horizon – beyond which is Rome – that the camera frames.

When the camera returns to frame Paul, it finds him already writing:

'I am in debt to the Greeks and the barbarians, the wise and the ignorant: and so for what is in me, I am ready to announce the Gospel also to you, who are in Rome ...' [Rom. 1:14–15]

At this point, above the sea, fading in, appears, as imagined by the heart that tends with all its power toward it, the image of Rome: that is, the boundless panorama of New York, with its skyscrapers that puncture the grey and stormy sky.

54–57 A.D.

64. Naples. Exterior. (Day.)

Here they are, the trickster brothers. In the middle of a crowd of ragamuffins, miserable peasants and subproletarians emerged from the enormous wormholes of the slums of the city, three faces, unheard, worm-eaten by misery, corruption, bestial innocence – and, of course, hunger. One of them is twenty-five years old, one between eighteen and nineteen, one thirteen or fourteen.

Their faces, while laughing, are the most scoundrelly, and the least trustworthy that can be imagined: in any case, they do not lack for a certain popular and superstitious respect, in the curiosity with which they listen to Paul speak, in a small meeting in the miserable crowd of the southern outskirts.

Paul speaks, contorted by his illness – he himself also rendered as miserable, hollowed-out, weak as those who listen to him:

'Therefore, remember that at one time you, pagans and non-elect in the flesh, called the "foreskin" by that which is called "circumcision", made by the hand of man in his member, remember that in that time you were without Christ, excluded from citizenship of elect men and foreigners to the agreements of the great promise, without hope and without God in this world …' [Eph. 2:11–12]

He continues – skipping a part of the Letter to the Ephesians from which this speech is taken – while the actions of the scene take place:

'Do not give the Devil a place. Let the one habituated to robbing not rob anymore …' [Eph. 4:27–8]

(And at this point the camera will fleetingly frame the faces of the above-mentioned swindlers.)

'… let him toil, rather, working with his own hands, to make something good to have to give to someone who is in need.

'Let no obscene word emerge from your mouth …'

(Framing as above)

'… but only good words that can serve, when it be necessary, for edification, conferring grace upon the listeners …' [Eph. 4:28–9]

Internal dissolve.

The three figures are still listening attentively to Paul, amidst the crowd of miserable people:

'Let every harshness and animosity, anger, clamour, and insult be placed away from you, with every genre of malice. On the contrary, be benevolent to one another, merciful, forgiving each other as God has forgiven you through Christ.

'Therefore make yourselves imitators of God, as beloved children, and walk in love, as even Christ loved you and offered himself for us "as an offering and sacrifice to God in sweet fragrance".' (Eph. 4:31–5:4) [Eph. 4:31–5:2]

(It is clear that 'the fragrance' around there has to be terrible: the people sweat and the sewers are uncovered.)

Internal dissolve.

By now Paul's speech to the poorest of Ephesus is coming to an end:

'Slaves, obey your masters according to the flesh, with fear and trembling, in the simplicity of your heart, as you would Christ.

'But you ought not serve to be seen, as those who want to be pleasing to men, but serve as slaves of Christ, doing by heart the will of God, serving in good will, as if serving the Lord and not men.

'You know in fact that everyone will receive from the Lord according to that which he will have done that is good, whether a slave or a free person.

'And also you, masters, do toward them the same things, setting aside threats, knowing that the Lord, theirs and yours, is in the heavens and that with him preferences among persons do not exist …' [Eph. 6:5–9]

Outline of a Screenplay

While he speaks, one of the crowd, close to the three scoundrels, looks at him with infinite tenderness, and with the attention of a dog who watches the master while he eats.

When Paul finished speaking, the man stealthily, as if doing something shameful – seeks to be pardoned with a slimy and radiant smile – gets close to the saint, stoops at his feet and, with a quick gesture, unlaces a strap from his shoe. He clutches it to his chest, and flees.

The three swindlers, sniffing the smell of good news, follow him – through the miserable alleyways of the poor malodorous southern city.

(This scene would require a very large number of extras. But it can be shot in real life: that is, drawing from the crowd of onlookers and then shooting it in true attitudes while observing 'the turning', etc.)

65. Naples. A wretched house. Exterior. (Day.)

They arrive in front of a wretched little house, on the extreme outskirts, amidst slums, gardens, and garbage dumps.

The thief of the shoe strap goes inside the hovel, in which the entire family awaits him: wife, a dozen children, half-naked with their bellies out, muddy, mean, and cute and funny as angels.

Through the open window in the brick partition wall, the three idlers observe what happens inside the wretched little house. In a corner, in a rickety and dirty crib, a little baby is stretched out – probably the last of the family, two or three years old.

He cries, almost hoarse, nearly voiceless, consumed by a fatal illness.

The father – followed by the wife who is full of hope, and all the children – comes close to the crib and ties Paul's shoe strap to a finger of this creature.

Miracle!

As soon as the strap is tied, the creature is suddenly cured – he claps his hands happily – and demonstrates a sudden desire to get down out of the crib and go into the hallway to play.

The family rejoices.

The three bandits at the window watch questioningly.

The father religiously collects from another corner of the hovel a basket full of every good from God (who knows what sacrifices he will have paid to put it together), and departs.

The three pals follow him again.

(The exterior of the scene will naturally be shot in a real-life setting – in the outskirts of Naples. The interior can still be reconstructed: but it is preferable – since it involves a subjective perspective, to shoot it therefore from a single point of view – to choose a real wretched house on the spot.)

66. Naples. Plaza. Exterior. (Day.)

Paul is continuing his speech to the Ephesians:

'Do not wish to become companions of the sons of rebellion. At one time you were darkness, but now you are the light in the Lord: walk therefore like sons of light – and the fruit of the light is precisely in every good, justice, charity And do not wish to associate yourself with the fruitless works of darkness, but rather struggle against them, since what is done by them in secret is shameful even to speak about. But everything against which one struggles is made visible in the light; everything in fact that comes to be made visible is light. For this it is sung:

Awake, O you who sleeps,

Arise from the dead,

And Christ will shine upon you …' [Eph. 5:6–14]

The poor man with the basket comes close, shyly, through the crowd, to the feet of Paul who speaks, and he deposits his gift:

there are other gifts as well. And the disciples of Paul thank him gently with their eyes.

The three convicts exchange looks darkly, simultaneously taken by a single, solemn, ecstatic inspiration.

67. Slum village in Naples. Exterior – interior. (Day.)

Amidst mangled and incomprehensible Neapolitan sentences, laughter worthy of the eighth circle of hell [Malebolge – Dante's eighth circle of hell from the *Inferno*], innocent blasphemies, etc., the Society of the Three is at work. With glue, ointments, pitch, mud, horsehair, straps, laces, rope, pieces of meat, they are intent on making up four or five old men and women as cripples and paralytics. They are playing a game shamefully, fetid scraps of the most disgraced subproletariat, etc., etc.

One old woman has scales on her eyes, blind (she is entrusted with a baby with a big belly, who appears to be a hundred years old, etc., with a stick); others, fake paralytics, are stretched over these old and dirty wooden carts that the boys have constructed by themselves, etc., etc.

Everything is ready.

68. A place on the outskirts of Naples. Exterior. (Day.)

The Three are preaching.

Before them is a small crowd that is listening.

Their faces are as sinister and innocently rascally as can be imagined. They have memorized certain lines of Paul's speech (to the Corinthians, scene 56) and they recite from memory.

Strangely: contrary to every possible forecast, these words in these blaspheming mouths do not at all lose their highest, holy

meaning. Rather, in some way they become even more sublimely mysterious.

In fact these speeches are glossed by musical phrases of high sacred music.

Finished speaking, the Three place their hands on the heads of the closest sick people who, all very happy, are healed and all sprightly, they express thanks and dance for joy. Their (fake) kin give their (fake) gifts, and soon they are imitated by other bystanders, all happy to be in the presence of this prodigy.

69. Another place on the outskirts of Naples. Exterior. (Day.)

The Three are again at work, like methodical charlatans and players.

They preach the holy words of Paul (other strands – the most beautiful and mysterious of the Letter to the Corinthians already cited: those concerning the resurrection and redemption) – and, then, in sacred concentration, they perform their miracles.

The gifts pour in.

But at a crucial moment, followed by his disciples (the ardent, gentle Timothy and the others) and by a crowd of the 'most dignified' faithful, Paul arrives. He does not take the thing at all in fun. Rather, he thunders with authority against the swindlers, pointing them out to the admiring crowd, some of whom are disappointed and about to come to blows. So much for our three poor devils, having seen that things have taken a bad turn, they run as fast as their legs will carry them, disappearing down the dusty road, as in a comic film.

Outline of a Screenplay

58 A.D.

70. Streets of Paris. Exterior. (Day.)

Paul, followed by his most faithful disciples, walks again through the streets of Paris. A woman (not seen at first, mysteriously gentle and kind) and a boy who holds her by the arm follow him. Thus we will know that they are Paul's sister and nephew.

Along chaotic and restless streets of a city in wartime, we find, almost as in a dream, the period of anguish and of death, of oppression and of genocide.

Paul walks, affected and in a hurry, through these streets, until he arrives in front of a house, with a small dignified entrance, and he goes in.

(This scene to be shot in real life, with a dozen extras.)

71. Paris. House of James. Interior. (Day.)

In James's house are gathered all the elders (or the leaders of the Revolution) in a typical clandestine meeting (absurd, given the time when it takes place: and this makes it so that the following sequence may be the most dreamlike and suspended of the film).

Paul embraces the disciples who are present, one after another in silence. All of them are moved – with tears in their eyes.

Finally one of the apostles breaks the silence, confronting the situation realistically. He says to Paul:

'Look, brother, all the Jews who were converted to our faith, they nevertheless remain jealously attached to the old Jewish traditions. So now, here, they slander you. They report that you induce the Jews of the diaspora to detach from the foundation of their tradition, that of Moses, that you dissuade them from circumcising their sons and from living according to Jewish customs. What will happen when it comes to be known that you are with us?'

Internal dissolve.

In a new light – the light of history and of the present and of a new language – the apostle continues to talk:

'Ours is an organized movement ... Party, Church ... call it what you like. Institutions have been established also among us, that we have struggled and continue to struggle against institutions. The opposition is in limbo. But in this limbo already are prefigured the norms that will make of our opposition a power that takes power – and just so it will be a good for everyone. We must defend this future good for everyone, accepting, yes, also the need to be diplomatic, shrewd, official. Accepting the need to be quiet about things that ought to be spoken about, not to do things that ought to be done, or to do things that ought not to be done. Not to speak, to hint, to allude. To be cunning. To be hypocritical. To pretend not to see the old customs that resurge in us and in our disciples – the old unavoidable man, wretched, mediocre, resigned to the least worst thing, needy of affirmations and reassuring conventions. Because we do not have redemption, but a promise of redemption. We are founding a Church.'

72. Paris. Parliament. Exterior. (Day.)

Paul passes with some of his disciples in front of the Parliament of Paris – perhaps headed there to preach, at one of his popular meetings.

But a large crowd gathers around him – a crowd of fascists, of old and reactionary faces, etc. The tumult grows ever greater – under the (for now) indifferent eyes of the police officers.

The crowd shouts angrily against Paul and his disciples:

'Israelites – on alert! Behold the individual who everywhere and to everyone announces doctrines against Israel, who despises the law and violates the Temple. Rather he profaned the holy place by bringing uncircumcised Greeks into it ...'

A lynching is about to occur – when one hears the sirens of the police, who intervene and begin to put the riot down brutally. The commander of the police asks what is going on, but in the uproar he doesn't understand anything. Now he gives the order to incarcerate Paul in a police van. The order is carried out.

The police van leaves followed by a police escort, toward the prison.

(This is one of the scenes that is organizationally most complex: three or four hundred extras in the centre of Paris are needed; plus, the police vehicles.)

73. Prison in Paris. Exterior. (Day.)

The crowd continues to riot in front of the prison in Paris – it is a true and real fascist demonstration:

'Kill him! This man is not worthy of living among us!'

(Cf. Note on the preceding scene.)

74. Prison office in Paris. Interior. (Day.)

'Kill him! This man is not worthy of living among us!'

The shouts of the rioting crowd enter the office where the commissioner (or a man of this type) is interrogating Paul:

'In the end, do you want to tell us the true motive of this riot that you have caused with your presence?'

He has a foul air of someone prepared for something illegal and dirty.

He asks the question again, exasperated, and when he continues not to obtain an answer from this Pharisee in a double-breasted suit who looks at him simultaneously with superiority and humility, he makes a gesture to one of his executioners, who approaches Paul, getting ready to beat him.

But Paul:

'Do you perhaps have the right to strike a Roman citizen before a proper interrogation?'

Another *éminence grise* is present there – in shadow, but at these words, he is disturbed, as an authority of a higher grade, and he addresses his foul inferior:

'Mind what you do, this man is a Roman citizen …'

'Is that so?'

Paul responds differently, out of an ancient legalism:

'Yes.'

The commissioner humbles himself, and says, fouler still, in confidence:

'To become one, I paid a sack of money …'

Paul:

'And I, I have it by right of birth, as a birthday present.'

The policemen look at him with respect like humble dogs.

(This scene to be filmed in the studio/on set).

75. Cell in the prison in Paris. Interior. (Night.)

Sleeping on a pallet in his cell – among other prisoners – Paul no longer seems to be the same man who, just a little while before, had so proudly spoken about his rights as an equal with the authority (opposition power against the power of the state apparatus) – in fact he is completely transfigured by his illness, he is a poor, miserable creature who moans while he sleeps.

But behold that God appears to him in a dream.

His mouth pronounces these words:

'Courage, Paul. You have rendered testimony about me in Jerusalem, you will render it about me also in Rome.'

(Cf. Note on the preceding scene.)

Diabolical scene.

76. Parisian lycée. Exterior. (Day.)

A pleasant, healthy, simple boy – while also being a student – namely, the son of Paul's sister – exits the school, with his companions, between sixteen and seventeen years of age.

On the street, there is the agitated air of days of strikes and political disorder (police jeeps – demonstrators who distribute or throw flyers, etc. – the liberation is imminent).

The boy, Paul's nephew, passing near a group of young men (with the air of paratroopers, students, and workers mixed up together), hears some of their sentences.

'We have to take him out, and tomorrow we'll do it, etc., etc. Now tonight, to the judges, etc., etc.'

The boy, obviously traumatized by recent events, etc., guesses what they are talking about – and for the rest, it is not difficult, etc., etc.

Now he begins to follow stealthily – as he will have seen done in police films – a group of these young thugs ...

77. Mansion of the High Priest and the elders. Exterior. (Night.)

A group of about forty people – honest bourgeois faces poisoned by hatred, and young thugs – advance along the street and enter through a luxurious doorway of the luxurious mansion of the 'High Priest and the elders'.

Paul's adolescent nephew watches them enter. And he waits, still with his schoolbooks under his arm.

78. Mansion of the High Priest and the elders. Some time later. Exterior. (Night.)

The boy has waited without tiring.

And behold the lovely company leaves the mansion. They

are euphoric. A rosy future awaits them. Order and normalcy, thanks to them, will be satisfied. Their pact, healthy and virile, will achieve the end that was proposed in the name of the law.

They finish – at least the group of the youngest and most violent – in a 'bistro'. They are already a little drunk, and they are going to drink more.

79. Bistro. Interior. (Night.)

The group of assassins sing in chorus – they are all drunk – a fascist song. Finished with that one, they chant an obscene one.

The boy who has followed them sets himself to sing with them.

Near him, singing at the top of his lungs, is a young man more or less his own age, dead drunk, who doesn't know whether he is in heaven or on earth: and in this unconsciousness he is no longer fascist nor anything else, he is a poor creature of flesh, humbly bestial.

Without realizing it, and perhaps not recognizing him, he embraces the boy who is sitting next to him, singing the dirty little song virilely along with him.

With such familiarity created, Paul's nephew, obviously upset by his heart beating, but without showing it, asks:

'So, we're going to take him out, right?'

And the other boy, with his voice broken and kneaded by wine, while the others sing at ear-splitting volume, confirms:

'Yes, tomorrow, when those Roman turds bring him from the prison to the courthouse …'

(Scene to be shot on set – it would be preferable, in order to achieve a true ambience, to have fifteen or so extras who are true Parisians.)

80. Prison of Paris. Exterior. (Night.)

Paul's nephew runs at breakneck speed along the street that leads to the prison, arrives in front, asks the guard to let him speak to the tribune. The centurion decides to let him pass.

81. Tribune's office. Interior. (Night.)

The tribune (that is, the *éminence grise* whom we have seen attend the interrogation of Paul and interrupt the beating) watches the boy, who is accompanied by the centurion, enter his office.

Centurion:

'He is the nephew of Paul. He says that he has something to say to you.'

The tribune dismisses the centurion, and remains in private with the boy:

'What do you have to say to me?'

'Lord, the Jews want to ask you for the favour of having Paul appear before the tribunal, on the pretext of informing you more fully on the facts concerning him. Don't believe them: it is a trap by a minority of fanatics who hope to kill him during the transfer. They are already ready: in their angry waiting, they only await your permission.'

'Go then. Don't worry. And silence, don't say anything to anyone!'

82. Prison in Paris. Exterior. (Night.)

A large police escort is prepared. In silence.

In silence Paul is brought out of the prison and made to get into an automobile, which departs right away, followed by the escort, thundering through the streets of the sleeping city.

83. Suburb of Vichy. Exterior. (Daybreak.)

It is daybreak. The police column, with the car carrying Paul in the middle of it, having crossed the countryside and the first still-sleeping suburb, arrives at the gates of Vichy (announced by a large placard) and enters the city.

It arrives in front of a dark building. Here Paul is made to get out and enter a new prison – which is not officially a prison, but, rather, a house arrest.

Here the procurator Felix, with his wife, awaits him – and Felix says to him, with a certain ambiguous kindness, that he knows everything (his speech appears in the pages of Acts 23:21–31) concerning Paul. He concludes: 'But you, what are you preaching? What are your arguments?'

And Paul, simply:

'Justice, chastity, the future judgement.'

The procurator Felix darkens, embarrassed (feeling obviously 'a conscience that is not tranquil') and mumbles:

'We will speak about this another time.' And he turns to his guards: 'Watch him, but allow him a certain liberty ... do not impede his brothers in faith from extending him some service.'

He leaves, with a courteous smile.

Felix having barely departed, the ringleader of the guards looks at Paul and, pointing after his superior who has just left, winks, rubbing his index finger against his thumb with significance.

60 A.D.

84. Suburb of Vichy. Interior. (Day.)

A wide, ambient shot of the 'gloomy building of Vichy' – we are thus, after two years, still at the same moment.

A huge car (for authority) stops in front, and a fat man gets out of it, followed by his guards.

[N.B. At this point, there is a jump, figuratively dreamlike, between the German occupation and the American one. Formally, it is the same thing. Power has the same face, etc. Thus to escort the new authority, no longer the SS, but American police officers.]

The fat man who enters the building of Vichy is the new procurator.

85. Interior of the building of Vichy. Interior. (Day.)

Paul is in the room of his house arrest. He writes. At an old but luxurious writing desk.

The new procurator enters and introduces himself:

'I am the new procurator, Festus. I come from Jerusalem, where I examined your case. Grave accusations against you arise there. But they are not in a position to prove any of them. Do you want to go to Jerusalem and be judged before me?'

And Paul, sure of himself, man of action, one who keeps to legal means, equal to equal:

'I am already before the tribunal of Caesar; it is here that I ought to be judged. To the Jews, I have done no wrong, and you know that very well, Festus. If I am guilty of some crime worthy of death, I do not refuse to die; but if nothing of that of which I am accused is true, no one has the right to deliver me to the Jews. *I call to Caesar.*'

'You have called to Caesar, and therefore you will go to Caesar, in Rome.'

86. Port of New York. Exterior. (Day.)

Apparition of New York, from the sea.

The transatlantic ship where Paul is embarked – accompanied by guards – docks at the wharf of the port, and Paul descends.

Awaiting him, on the wharf, is a delegation of Jews living in Rome: their handshakes are not only courteous, but also affectionate and fraternal.

Then the group is lost amidst the immense crowd of the port of New York.

(The scene naturally to be shot on location.)

87. Exterior of a small hotel in New York. Exterior. (Day.)

The camera will take its time to describe, albeit briefly, the location of the small hotel where Paul lodges: Manhattan, on the borders of the Village, on the West Side, an apocalyptic and very impoverished place. But with particular love the camera will frame the hotel itself: which possesses a curious and poignant similarity to the small hotel where [Martin] Luther King [Jnr] was killed.

A (black) American policeman walks calmly and gently back and forth on the balcony of the second or third floor, onto which the door that leads to Paul's small apartment opens.

88. Interior of the small hotel in New York. Interior. (Day.)

In his room Paul is talking with Jewish delegates who listen to him fraternally (Acts 28:16–22).

Paul:

'Brothers, without having done anything against the people nor against the customs of the fathers, I, chained in Jerusalem, was

placed into the hands of the Romans; those ones, having examined me, even they wanted to release me, not finding in me anything which would merit either death or prison. But my compatriots were opposed, and I saw myself constrained to appeal to Caesar: I certainly did not move to accuse my own people!' (The hearers of the word 'appeal' are a little bit angry.) 'And now I have asked you to come to me, for no other reason than to see you and tell you that I bear these chains only because I preach the Messiah, the hope of Israel.'

The delegates answer:

'As for us, we have not received news from Judea nor messengers who deliver to us bad information on your account. It seems to us, however, necessary to hear from you what you think; because here one finds, as regards your sect, opposition from everywhere.' [Acts 28: 17–22]

89. Representatives' salon of the Italian embassy. Interior. (Day.)

The Jews residing in Rome have a luxurious seat (a type of embassy just like the Italian embassy in New York). Here everyone is gathered (about two hundred) to listen directly to Paul's word.

As in all these last scenes, Paul appears in the clothing of the organization, of ex-Pharisee, strong, self-possessed, diplomatic, in sum not a saint, but a priest. He is seated at the luxurious, large, and solemn table of the presidency (albeit always guarded by the gaze of American police officers) – and he pronounces his speech in almost official tones (albeit still on the path of his powerful and inspired impetus).

This speech will be composed of text from the Letter to the Hebrews: not the entire letter, of course; but synthesized, across a selection of two or three culminating points, which a *series of internal dissolves* articulates.

The audience of the Hebrews remains for the majority indifferent, cold, or hostile. Some even disapprove openly.

The final words of the speech are still taken from Acts 28:23–31:

'The Holy Spirit was right to say to your fathers: You hear with your own ears and do not understand, look with your own eyes and do not see, because your heart has become unfeeling, your ears have become hardened and your eyes are closed in order not to see, not to hear, not to understand, not to be converted and healed by me ... Let it be known therefore that this salvation of God – refused by you – will now be communicated to the heathens who listen to it obediently.' [Acts 28:25–9; Isaiah 6:9f.]

Having said these words, Paul, darkened, anguished, gets up and, uncertain, leaves: the others also leave the room, discussing a great deal among themselves.

(This setting can be reconstructed even in a theatrical set; it would be preferable nonetheless to find a real-life setting in New York.)

90. Interior of the small hotel in New York. Interior. (Day.)

On his pallet, in that desperate room, deprived of every beauty, lost in the heart of New York, Paul is taken by his illness: he is ashen, exhausted, rendered ugly and somewhat repugnant by vomit and tears: the miserable face of an old child, of the refuse of humanity. The pain is unbearable and he complains.

One sees passing back and forth on the balcony – near the glass door, which is very much in the style of a gangster film – the black police officer, lounging and pleasant. He sings or whistles, improvising. But then the pity, which he tries ineffectively to vanquish, prevails: and he presses his face, already divinely squeezed like that of a gentle animal, against the glass.

Outline of a Screenplay

Paul realizes it, and smiles weakly at him.
Internal dissolve.

Paul's room is now full of people: they are all poor – perhaps the servants of the hotel, or their relatives and friends. The majority of them are black. (The black police officer is gracefully leaning against the door-frame.)

Paul is disfigured by illness, but succeeds equally in speaking: he improvises, inspired, in fragments (just like perhaps his listeners are in the habit of improvising their songs) and it doesn't matter if the speech is elliptical and illogical (this is configured like the 'birth' of concepts that will then be expressed in the Letter to the Romans from which they come, confused and without order, *like before being written*):

> I will call those who are not my people, my people,
> And she who is not my beloved, my beloved;
> And it will be confirmed in the place where it was said to them:
> You are not my people,
> There they shall be called sons of the living God! [Rom. 9:25–6; Hosea 2:1, 2:25]

.

'The gentiles, the non-elect, those who did not seek justice have obtained justice, that truth that comes from faith. The believers, the elect, instead, who also followed a Law of justice, did not arrive at the Law. And why? Because they sought to arrive there not by faith, but by works …' [Rom 9:30–2]

.

'They are enemies of God, for their advantage, but insofar as election is concerned they are beloved, thanks to their fathers: because the gifts and the call of God are irrevocable.' [Rom. 11:28–9]

'Like a time when even you did not believe in God and now, through their incredulity, you have obtained mercy, just so even

now these who have not believed so that through mercy displayed toward you, they also obtain mercy.' [Rom. 11: 30–1]

'Because God has closed up so many in disobedience, in order to give mercy to all.' [Rom. 11:32]

.

63 A.D.

91. Tribunal of New York. Interior. (Day.)

Paul is seated on the bench of the accused. Around him are American police officers.

Beyond the enclosures, a large public awaits the sentence. Poor blacks and whites, the 'catechized' of his little hotel on the West Side, several American intellectuals, many young people from the Village, multicoloured, desperate – angels of corruption as protest; and finally a dense group of Jews, in double-breasted suits, adversaries but not enemies of Paul, indeed fraternally close to him in waiting for the sentence.

Paul, seated on the bench, suffers visibly from the spasms of his illness, but he succeeds in mastering them. His face, however, is humiliated and desperate like that of the innocent blacks, the doped and perverse young people.

The Tribunal comes out, and the President reads, according to the American formula, an acquittal.

The poor, the blacks, the young people of the Village rejoice: joy is also in the eyes of the Jewish dignitaries.

92. Small hotel in New York. Exterior. (Day.)

In the courtyard of the small hotel on the West Side, there is an air of expectation.

Outline of a Screenplay 91

There are many other people, beyond the usual guests.

But these people are very curious, and one would not say they were at all respectable.

There are blacks, with a dangerous and thuggish air, with curious hair and dressed in a somewhat wild fashion; there are young 'beats' and 'hippies', dirty and provocative enough to turn the most liberal of the bourgeois absolutely furious; a group is gathered around a girl who sings, playing a guitar, a song against every kind of power. And until this point, it is bearable. But others, in a corner, standing aloof, are smoking; and some are already clearly prey to the stupor of drugs. Yet others in a group are chattering in a lively way: witty discussions among a group of homosexuals, very feminine and made-up, with some young prostitutes, dressed somewhat in costume, it's the same as the excess of their violence, of their virility; around them are the wrecks of various types: old drunks from the most unfathomable slums; old whores reduced to beggars; corrupt girls, in flight from their families, some very beautiful but marked by a desperate destiny; there are also some intellectuals, recognizable not by dress, but by their dull faces and their attentive eyes.

Into the middle of this whole crowd, Paul descends – still atrociously tormented by his illness. And the crowd clings around him, respectful and eager to know and to understand – according to the almost mystically democratic habits of the Village.

Paul opens his mouth and begins to speak:

'No one of us lives for himself and no one dies for himself: because if we live, we live for the Lord; if we die, we die for the Lord. Thus, whether we live, whether we die, we are in the Lord. Indeed, it is precisely for this that Christ died and was resurrected, to be Lord as much of the dead as of the living.' [Rom. 14:8–9]

'But you, why do you judge your brother? And also you, why do you despise your brother? In fact, all will appear before the tribunal of God …' [Rom. 14:10]

'So each of us will render account to God for himself. Therefore let us not pass judgement any longer on one another, but think rather of not placing an obstacle nor giving a scandal to your brother ...

'I know and am persuaded in the Lord, that nothing is impure in itself, but if a thing is considered impure, by one who believes it so, it is impure ...' [Rom. 14:12–14]

'Happy is he who does not condemn himself in what he approves!' [Rom. 14:22, adapted]

'But the one who is doubtful ... he is condemned, because he does not act with conviction: everything that does not derive from firm conviction is sin ...' [Rom. 14:23, adapted]

93. Large meeting room in the Village. Interior. (Day.)

This meeting room could be a theatre, or a cinema, or an immense cellar: or, even better, a ballroom.

A huge crowd packs the space: it is the identical crowd already described in the small hotel on the West Side, which has multiplied.

This time Paul comes to speak in all his power and authority as a big organizer, as apostle, as founder of the Church. His illness is appeased: his face radiates strength, security, health, and in some fashion, a form of violence.

The crowd greets him in friendship and fraternity, and he begins to speak, on the platform where perhaps an orchestra usually plays, before a microphone (as does, let's say, Ginsberg):

'Let everyone be subject to the superior authorities, for there is no authority that does not come from God, and those that exist were instituted by God.

'Therefore the one who opposes authority resists the order established by God: and those who resist attract condemnation upon themselves.

Outline of a Screenplay

'Those who rule ought not make us fear good actions, but bad ones. Do you want not to fear the authority? Comport yourself well, and you will receive his approval. He is in fact the minister of God for your good. If instead you act badly, fear it: it is not for nothing that he carries the sword, but, being the minister of God, he ought to punish the one who does evil. It is necessary therefore to be subject, not only for fear of punishment, but also for the motive of conscience. For still the same motive, you ought also to pay your taxes, because they are public functionaries of God those who are entirely employed in this office. Render completely what is owed: to the one who is owed tax, the tax; to the one who is owed a levy, the levy; to the one reverence, reverence; to the one honour, honour.' [Rom. 13:1–7]

As Paul speaks, the audience, which had come to listen to him with love, remains at first surprised, then shocked, and finally, it angrily rages, whistling, shouting, singing.

In the chaos of indignation, vibrant and, in fact, in that place, justified, the words of Paul are lost; the last sentence which he succeeds in pronouncing can barely be heard:

'... Night is already advanced, the day is near. Let us therefore divest ourselves of the works that are done in darkness and put on the armour of light ...' [Rom. 13:12]

In the confusion (there is no longer anything that seems like a protest of young people who are on the right side: it is infinitely more anguished and dreadful than any uproar or actually any fascist lynching), the agitated, or ironic, or bitter interventions of some intellectuals and some young people are heard:

'Send him right back to Spain, the Spain of Franco: there, certainly, they do not whistle.'

'But maybe he does it for diplomatic reasons ... in order not to be taken out like [Martin] Luther King, to maintain good relations with the authorities, not to disturb them ...'

'Still worse, religion and diplomacy are a contradiction in

terms: this disdain of public life, which consents to flatter power in order to find a modus vivendi with it, cracks the same metaphysical totality that renders it possible ... In fact, metaphysical extremism and practicality coincide: but existential practicality is one thing, political practicality is another. Existential practicality is the other face of metaphysical religiosity. But a political error, deteriorating practical life also deteriorates religious thought: and worse still when this political error consists in an acquiescence, in a vile compromise with reaction, in a complicity with power.'

'What can you expect from this man? He is legalistic to the core, even in his preaching. The archetype of the idea of power coincides with the archetypal idea that he has of God.'

'His preaching is completely authoritarian: his declarations of weakness are either narcissistic or passages of rhetorical art.'

'Meanwhile, he, like our truly democratic young people, ought to renounce being a leader!'

'Ah, he has in his head a hierarchical world in the most narrow and rigid sense of the term! Imagine if he accepts anonymity: that is, changing his name each time that he founds a church, in a fashion to begin again at zero, without the authority that comes to him through his successes (just as our youth of the student movement do).'

'He accumulates authority upon authority: far from changing his name and representing himself each time as an unknown, he does nothing but accentuate his paternal function.'

'Power for him is everything.'

'He is the founder of Churches: he is obsessed by institutionalizing.'

'But every institution is in itself antidemocratic: democracy has no place. His definitions don't have a semantic field: therefore by necessity they have to be imprecise. And his institutions, if they are, have to be always unstable, indefinite, open, in movement.'

'Reality is a quality, not a quantity!'

Outline of a Screenplay

'And to suppose that he would not even understand the letter of our critiques.'

'In fact he tries to define and to close everything: his language attests to it: inspired and imprecise language, that's true, but at the same time so rigidly codified that when some new word appears in his speech, it is a cause for screaming "miracle".'

'Is it possible that he does not understand that today, here, a code cannot exist and cannot be accepted, not even if it is a code of revolutionary language? That revolutionary language is invented day by day? And that formulas which are inevitably born, cannot have more than a day or a month of life?'

'This is nothing: is it possible, rather, that he came to preach a clerical church here, where, if the need for a church is felt, it can only be ecumenical: and that if something has to be taught, in principle, it can only be resistance to authority, to every genre of authority?'

Internal dissolve.

The large room is partially emptied out. Yet a tumultuous crowd is still debating.

In a corner, surrounded by a group of young people and intellectuals, who still want to ask him questions and listen to him, is Paul. He has again lost his security as 'leader', and humbly speaks to the others, he is suffering, humble, as though talking to himself:

'What ought to be said now? Is the Law sin? Certainly not. I do not know sin except by means of the Law. In fact, I would have been ignorant of concupiscence, if the Law had not said: Do not desire ...

'But sin, acquiring consciousness of itself through this precept, has caused in me every sort of cupidity, because outside the Law, sin is dead.

'Yes, I lived once outside the Law. But when the precept came, sin was awakened and I died ...

'So the precept, having given me the motive that would guide me to life, drove me instead to death …

'Since sin takes the opportunity that it might seduce me by means of the precept, and with this I am killed.

'The Law therefore is holy, and the precept is holy, just, and good …' [Rom. 7:7–12]

Feet that are walking on a street in Rome (that is, Jerusalem) are framed [by the camera]*: then the feet stop in front of a door. It is the door of Luke's building. The visitor is seen from the back, and, for the whole episode, will be seen from the back. He is, as we will see, Satan. He enters the building and goes up to Luke's apartment.*

A long dialogue between the two: grinning sarcastically at his boss, Luke summarizes the continuation of Paul's story. Practically the goal has already been reached. The Church is founded. The rest is nothing but a long appendix, an agony. The Destiny of Paul doesn't interest Satan: let him be saved and go to Paradise anyway. Satan and his hired assassin laugh sarcastically, satisfied. Luke gets up, takes a bottle of champagne from a cabinet, and the two of them repeatedly drink a toast to their *Church. They drink and get drunk,* evoking *all the crimes of the Church: a huge, long list of criminal popes, of compromises by the Church with power, of bullying, violence, repressions, ignorance, dogmas. At the end, the two are completely drunk and they laugh thinking of Paul who is still there, travelling around the world preaching and organizing.*

64–66 A.D.

Interview in which one speaks of the reason for making a film about Saint Paul. All the crimes and faults of the Church as a story of power are nothing in the face of the faults of today in which the Church passively accepts an irreligious power which is liquidating it and reducing it to folklore (cf. articles in Corriere della Sera, *to be cited in full).*

94.

A mysterious sequence/intermezzo begins here.

We see Paul, always in long shot, travelling again to most of the places he had already visited; speaking, but at a distance, so that his voice arrives jumbled, faint, and inaudible; meeting old friends and embracing them; entertaining with new friends, etc.

94a. Naples. Centre and suburbs. Exterior. (Day.)

Some passages (with actions as above) for some Neapolitan places: of these, some are well-known, others unknown. (Timothy is seen, as are other followers of Paul.)

94b. Geneva. Centre and suburbs. Exterior. (Day.)

Some passages, as above. (At least Aquila, Priscilla, other intellectuals can be recognized.)

94c. Another city. Centre and suburbs. Exterior. (Day.)

Some passages, as above (among completely unknown people).

95. New city. Centre and suburbs. Exterior. (Day.)

Some passages, as above.

But this time, still in long shot, a rapid and ineluctable scene occurs, as in dreams. A police patrol suddenly approaches a group with which Paul is speaking, attacks those present with inaudible violence, disperses them by striking them 'savagely' with nightsticks, arrests Paul, loads him onto a jeep, which disappears, still in long shot, down the road of that anonymous neighbourhood of that anonymous city.

96. Port of New York. Exterior. (Day.)

Reappearance of New York.

The skyscrapers tower over the port, in the gloomy air.

The transatlantic ship in which Paul arrives, accompanied by a police escort, approaches the wharf.

Paul, handcuffed, looks down from the deck onto the wharf through the crowd: but his eyes, at first full of hope, slowly become lost and frightened. And they fill with tears. There is no one awaiting him. He is alone.

Amid the police officers, he descends along the gangway, exhausted, rendered almost a shadow by the illness of his body.

They load him into a police jeep, which is lost in the traffic of the immense port.

97. Prisons in New York. Exterior. (Day.)

The escorted jeep stops in front of gloomy New York prisons, where common criminals are locked up.

Paul is made to get out of the jeep and enter.

98. Prisons in New York. Interior. (Day.)

Paul, escorted by wardens, walks along the galleries which overlook the internal courtyard of the jail. He is introduced into a cell, amid common criminals, who look at him with the perilous hatred of the old inmates for the new arrivals.

Internal dissolve.

Paul is bent over on his pallet; he has on his knee a piece of paper, and with the trembling hand of a sick person, he is writing:

'Everyone has abandoned me ...'

Internal dissolve.

It is night, Paul's cellmates sleep, untidy and sweaty. Paul is

still bent over the miserable scrap of paper where he writes with a trembling hand:

'In Christ I suffer pains and humiliations that have brought me to the chains, as if I were a common criminal: but the word of God is not enchained.' [2 Tim. 2:9]

67 A.D.

99. Prison in New York. Interior. (Day.)

In his room, the director of the prison (in any case, one of the authorities who has followed in succession – all different and yet equal – throughout Paul's life – the desperate and slimy faces of the servants of Power) is reading a letter.

In front of him are other subordinate 'servants of power', as if awaiting orders.

The boss raises his eyes with dispatch, and completely dissociated – justified, that is, by obedience – says:

'We have to get rid of him.'

100. Prison cell in New York. Interior. (Day.)

Paul is still tormented by illness: his face – swollen, white, with a long beard – could not be distinguished from that of a common criminal.

A warden opens the door, looks with hatred at Paul and announces to him:

'You can go. You are free.'

Paul collects his clothing, in silence, and follows the warden along the gallery.

101. Prison in New York. Exterior. (Day.)

Paul leaves the prison, and also at the same time, looks around to see whether someone is waiting for him. But all around, everything is deserted. Only passers-by who walk hurriedly in front of that sad building.

Paul's eyes, where perhaps a little absurd hope was shining, mist over and fill up again with tears.

Staggering from the spasms of illness in his body, he walks along the sad street surrounded by the huge, grey buildings.

Someone follows him, as if tailing him.

102. New small hotel in New York. Exterior. (Day.)

The small hotel where this time Paul has taken lodging extraordinarily resembles the one from the first time; only this time it is absolutely identical to the one where [Martin] Luther King [Jnr] was assassinated. (Insofar as it is possible, I would like to shoot this sequence right in the same hotel in Memphis where [Martin] Luther King was assassinated.)

On the balconies, in the internal courtyard, there are more or less the same people as in the other. One can see, below, the person who had tailed Paul.

103. Room in the new small hotel in New York. Interior. (Day.)

In the squalid little room of the hotel where he has taken up lodging, Paul is intent upon writing. A strong inspiration has taken him, and he writes quickly and passionately. (All the following lines are taken, *passim*, from the Pastoral Epistles):

'While hoping to come to you as soon as possible, I write these things to you, because, if I am delayed you will know how you ought to comport yourselves in the house of God, which is

Outline of a Screenplay

precisely the church of the living God, pillar and foundation of truth.' [1 Tim. 3:14–15]

While he continues to write, we see on another sheet, the destination of the letter:

'Paul, Apostle of Christ Jesus by command of God our Saviour and of Christ Jesus our hope, to Timothy, true son in the faith ...' [1 Tim. 1:1–2]

104. Naples. Various exteriors. (Day.)

Under the voice that reads the letter to Timothy, the places of Ephesus (that is, Naples, centre, suburbs, and surroundings) appear, where Timothy now is 'pastor'.

We see the plaza where Paul preached for the first time in Ephesus.

We see the places where the three subproletarians, false saints, undertook their business.

We see the places (of the sad, miserable suburbs) where Paul, enraged, drove them out.

We see the place – imprecise and mysterious – in which Paul passed for the last time.

Then we see other, unknown places: in the suburbs, stinking and scabbed, full of emptiness, fetid old gardens, formless and half-crumbled tenements, large clearings blinded by the sun – slowly, headed toward the centre, disordered, chaotic, too old or too new, with alleys lost in the mud of history, and desolate skyscrapers in the dust ...

Until we see the baroque palace that is the See of the Bishop.

Over all these images the calm and inspired voice of Paul continues to resound:

'You become a model to the faithful in word, in conduct, in charity, in faith, in chastity ...' [1 Tim. 4:12]

.

'Remind the faithful to remain subject to the powers and the authorities, to obey, to be ready for every good work, not to bad-mouth anyone, not to be litigious, but yielding, demonstrating every meekness toward all men.' [Titus 3:1–2]

.

'As many as are under the yoke as slaves, let them esteem their masters as worthy of every honour, so that the name of God and our doctrine not come to be blasphemed. Those then who have believing masters, let them not lack respect for them because they are brothers, but serve them all the better ...' [1 Tim. 6:1–2]

(Of course there will be a continuous analogy between these words and the images above; an image of the poorest people on miserable streets will correspond to the word 'slaves', the image of mansions in the city centre will correspond to the word 'masters', etc., etc.)

105. Inside the Bishop's mansion in Naples. Interior. (Day.)

Timothy is the Bishop. Dressed in prelate's clothing and crimson skullcap, he is seated at his desk, powerful, luxurious, neoclassical, but still full of a sensual and apocalyptic baroque heaviness – in the corner of a luxurious studio, with frescoed walls from the seventeenth and eighteenth centuries, displaying Christs, Angels, Hierarchies of Saints, clouds, haloes (the camera will capture the details of all this).

Bishop Timothy is reading a letter which Paul has sent to him: his gaze is still that gentle, bewildered, pure gaze of the apostle: nevertheless, with his age, a kind of dust has settled over him, a certain inexpressiveness ... Even he is like a little bit of wax, like the Christs, the Angels, the baroque and neoclassical Saints fixed upon the walls or on the vaults of his rich house.

Paul's voice continues to resound:

'As far as the bishop is concerned, it is necessary that he be irreprehensible, husband of a single wife, temperate, prudent, dignified, hospitable, capable of teaching, not dedicated to wine, not violent but indulgent, peaceful, disinterested ...' [1 Tim. 3:2–3]

'Do not reprimand an elder harshly, but exhort him like a father; exhort the young like brothers; old women like mothers, young women like sisters, in all chastity.' [1 Tim. 5:1–2]

106. Church in Naples. Exterior. (Day.)

Against the sky, the detail of the baroque bell tower of a church in Naples rises up: a bell tower wrought and crumpled like a cake, chipped, faded pale red, consumed by rain and sun.

Over the immobile bells, Paul's voice resounds:

'I advise first of all that supplications, prayers, petitions, thanksgivings in favour of all men be made, for kings and all those who are in authority, so that we can spend a calm and tranquil life, with every piety and propriety.' [1 Tim. 2:1–2]

But suddenly the bells begin to ring: violently, deafeningly – the sky is invaded by that terrible din – joyous and mad – at once desperate and habitual.

Paul's voice is almost no longer heard, swallowed up by the noise. Only a few words are still barely audible:

'Teach what conforms to the holy doctrine: that the old men be sober, serious, prudent, sound in the faith, in charity, and in constancy.' [Titus 2:1–2]

107. Church in Naples. Exterior. (Day.)

While Paul's voice continues to read the letter – incomprehensibly, imperceptibly, choked – we see now, in full shot, the solemn church, baroque and neoclassical as it is, full of all its terrible and foolish, splendid and depressing anti-reformist violence.

From a street that ends in the Church's plaza arrives a procession: with all its papers in order, banners, a most heavy statue of the Madonna, carried on the backs of young men with the faces of jailbirds, endless rows of Beguines, scantily dressed and dishevelled like Erinyes, under their anguished black veils, and then all the carnival, costumes: communicants, daughters of Mary, affiliates of the Good Death, etc.

The camera will frame all these particulars, while the procession, to the din of the bells, enters the church.

Barely perceptible, but firm, Paul's dogmatic warning resounds:

'Let the old women have a comportment that suits people blessed by God: let them not be slanderers nor drunkards, but rather examples of goodness, in order to teach the girls to be wise, to love their husbands and their children, to be prudent, chaste, attached to the house, good, submissive to their husbands, so that the word of the Lord not be besmirched.' [Titus 2:3–5]

.

'Also the youngest ones, exhort them to be prudent in everything ... Integrity in doctrine, gravity in conduct ... In this way our adversaries will remain confused not having anything to find fault with our concerns ...' [Titus 2:6–8]

.

(Also this time the words coincide, contradictorily, with the images: women, old men, young people who are mentioned, are those represented in the 'documentary' of the procession.)

108. Interior of the church in Naples. Interior. (Day.)

While Paul's voice continues to resound (always barely audible) the documentary about the ecclesiastical function continues, which, albeit in an essential way, embraces the entire clerical world.

Outline of a Screenplay

In grand pomp, there is Timothy, dressed literally in gold, crushed under the mitre, almost unrecognizable.

And all around the multicoloured and magnificently carnivalesque chorus of other priests.

The pretty altar boys who serve mass.

The (adorable) old women of the people who pray at their pews.

A group of authorities: high officials, puffed up like turkeys in their grand uniforms; political men, in their black double-breasted suits, with vulgar and hypocritical old faces; the throng of their bejewelled ladies and their servants, etc., etc.

The altar encrusted in gold – a true and real golden calf – full of baroque affectations and neoclassical flourishes, work of total unbelief, official, threatening, hypocritically mystical and glorifying, clerical, of the master.

And Paul's voice continues undaunted to give his pastoral precepts:

'I want then that in every place the men pray, lifting up toward heaven pure hands, without anger or a spirit of contestation. In the same way let the women act with a decorous attitude; let them therefore adorn themselves with modesty and moderation, not with braids and gold ornaments or pearls or sumptuous clothing, but with good works, as befits women who are converted to piety.' [1 Tim. 2:8–10]

..........

'Then know this: in the last days difficult times will arrive suddenly. Men in fact will become egoists, lovers of money, vainglorious, arrogant, blasphemers, disobedient to their parents, ungrateful, impious, without love, irreconcilable, slanderers, unrestrained, merciless, not lovers of good, traitors, arrogant, blinded by the fumes of pride, lovers of pleasure more than God: people who have the appearance of religion, but who have disavowed the truth of it.' [2 Tim. 3:1–5]

109. Bell tower against the sky. Exterior. (Day.)

The bells stop ringing. The last tolls vibrate, deep and blind.

Then the bells hang immobile against the sky: sharp, Paul's voice resurfaces, continuing to give his instructions, until concluding:

['This is the task which I entrust to you, Timothy, my son: conform to the prophecies pronounced concerning you, so that basing yourself on these, you fight the good battle, conserving the faith and good conscience.' {1 Tim. 1:18–19}]

Perhaps all of the above is to be excluded.

Instead, Paul, after having written the letter/testament to Timothy, goes out to take a walk. It is the first time that he does something useless and disinterested. He arrives at Central Park. He observes everyday life. Everyday things, events, characters, occurrences – outside of every history and religion.

He stops before a children's carousel that goes around and around, accompanied by organ music. Then he leaves. He goes into a bar. He drinks a Coca-Cola. He goes out. And once again on the street, he re-enters his small hotel, exhausted, worn out, but with a new gentleness. He goes into his room.

110. Room in the new small hotel in New York. (Day.)

Outside the small hotel, in the interior courtyard, together with the usual, humble, and anonymous people – near the door to a lavatory – there is the man who tailed Paul. With him are two or three men, of calm attitude, who are smoking.

Paul, passing in front of them, goes into his room.

[In Paul's room, meanwhile, some other people come to gather: humble people – servants, white and black, and intellectuals and young people.

Pale, exhausted, degraded by his illness, Paul is speaking – like

another time before, in an analogous room – but as if in 'trance' and delirium – he, a man so systematic and so rational, now in a fit of inspiration.

The words he says are taken piecemeal from here and there in the letters (not used in other preceding scenes): the most beautiful and sublime passages ... although without a real logical connection between them ... as if indeed Paul were improvising in a rapture ... or, better, as if he were thinking aloud ... allowing nascent thoughts – which would then have been collected, ordered, and rationalized, in sermons – to escape his lips in a pure state ...

Paul:

(fragments collected from the highest and most sublime, collected from here and there in the letters, as high and culminating points).

Having pronounced these last words, Paul is vanquished by his illness: all covered in icy sweat, and white in the face, he loses his senses. Kindly, his friends help to lie him down on the bed and then slowly leave the room – going out on the bare balcony where the desperate sun beats down on the huge city, anonymous as misery and perdition.]

111. Room in the new small hotel in New York. Interior. (Day.)

Here – still with the face of an ailing person, of a reject, so different from the great organizer and theologian, powerful and sure of himself – he sits at his small writing desk, and inspired and sick, begins again to write his interrupted letter.

'As far as I am concerned, I am already poured out in libation and the moment has arrived when I ought to release the sails. I have fought the good fight, I have finished the course, I have kept the faith. For the rest, the crown of justice is already in reserve for me which the Lord, the just judge, will consign to me in that day;

and not only to me, but also to all who have loved his manifestation'. (2 Tim. 4:6–8)

Strained but with a strange and serene sweetness, he gets up from his small, poor writing desk, and goes toward the glass door which leads out to the balcony and from which a desolate ray of sun enters the room.

112. New small hotel in New York. Exterior. (Day.)

Paul goes out onto the balcony, as if to rest a little, to enjoy a little peace and sun. He looks around, with a sense of profound calm in his eyes – as if he were one secretly content with having brought something to an end well and with satisfaction – perhaps he thinks of the letter he has just finished – and he already has something new in mind to write ... For the rest also all around him there is a profound everyday peace, lost in light and time.

Suddenly two violent, piercing gunshots ring out.

The door of the lavatory is still swinging back and forth: the man who fired has barely disappeared.

Paul falls down on the balcony, immobile in his own blood. He suffers a brief agony. And then very quickly any sign of life is lost in him. The pavement of the balcony is uneven. The blood coagulates in a crack and begins to drip down onto the pavement of the courtyard. There is a small rosy puddle, in which the drops of Paul's blood continue to fall.

Note on the Text

The original typescript of *Outline of a Screenplay for a Film about Saint Paul (in the Form of Notes for a Production Director)* – its first and definitive title – is one of a few texts by Pasolini that are dated at the bottom by the author himself: Rome, 22–28 May 1968.

In the first copy there is a further clarification: Rome, 22–28 May 1968 (first draft) 31 May–9 June (correction).

In the same period, even if not on the same days, is the *Plan for a Film about Saint Paul*.

Personal vicissitudes and objective obstacles prevented Pasolini from realizing the work.

In 1974, it seemed as though the film would finally go into production, new production companies having come forward ... but the estimated costs ended up being too high for a subject this 'risky', and it was set aside. While negotiations were in progress, Pasolini examined the work and made some changes to it. This intervention into the text was not completed, the corrections were made in ink on the earlier draft, and the amplifications and substitutions were only sketchy.

Pasolini had the idea of publishing this 'unrealized film' but there was also his intention to restructure it into a finalized format. In sending *Saint Paul* into print, one cannot not take into account

the revisions made by the author. It is possible to single out two substantive changes: one that concerns the settings, the other concerning a particular turn in the narrative.

In the first version, Paris in the years of 1938–1944 replaced ancient Jerusalem, while in the revision, Paris became Rome; and just so the Rome of the first draft became Paris; meanwhile, Barcelona became Lugano, and Vichy became Viterbo, while the port of New York became the airport of New York. Obviously, changing the city also changes the buildings between which the characters move: the Palace of the High Priest and the elders is identified with the Vatican, the Parliament of Paris comes to be replaced by the Palazzaccio of Rome, etc., etc.

These changes were not dictated by production pressures: there was in Pasolini an exigency toward 'the present' that brought him – after six years – to historical alternatives and different settings.

At the narrative level – apart from an investigation into the figure of Saint Paul (infancy, relationship with his father, adolescence, etc.) – appear new scenes with Satan, devils, and a diabolical instigator. These scenes replace others or are inserted into the old structure.

In the attempt to restore in the most correct fashion the spirit of the work as it matured in the last intervention by the author, the corrections and changes are completely reported; square brackets indicate scenes probably destined for suppression or new adaptation.

The changes of city and place are specified with clarity by Pasolini and are indicated in this note; instead, references to settings and descriptions were not updated since it was preferable not to report these changes in the published text.

Afterword: Appropriation's Excess, Paul of Tarsus for an Age of the Capitalization of Mastery

Ward Blanton

Tell me, those wanting to be submitted to law [*hoi hūpo nomon thelontes einai*], do you not listen to the law?
<div align="right">Paul to the hesitant partisans of Galatia[1]</div>

In Lacan's words, the law is the same as repressed desire. The law cannot specify its object without self-contradiction, nor can it define itself with reference to a content without removing the repression on which it rests. The object of law and the object of desire are one and the same, and remain equally concealed.

The fact that anarchy can only exist in the interval between two regimes based on laws, abolishing the old to give birth to the new, does not prevent this divine interval, this vanishing instant, from testifying to its fundamental difference from all forms of the law.
<div align="right">Deleuze on Sacher-Masoch[2]</div>

1 Galatians 4:21.
2 Gilles Deleuze and Leopold von Sacher-Masoch, *Masochism: Coldness and Cruelty and Venus in Furs* (New York: Zone Books, 1991), 85, 87.

In many ways and necessarily to multiple ends, it is the moment to seize upon an opportunity to (re)stage a work which the great Pasolini, by chance, could not himself fund. If so, our own setting into place of imaginary *mises-en-scène* for a screenplay Pasolini left behind would immediately set in motion a complex comparative machinery, whirring away to effect an operational wonder about the now-time within which chance occasions and imaginary props afford a chance to bring a screenplay, not to mention an apostle, to life again. Pasolini wrote in his notes for this screenplay, in fact, of a kind of *inevitability* of 'transposition', continuously emerging 'mutual implications', and a retroactive demand for a new 'coherence' over these 'series' produced by the very unleashing of 'analogy'.[3] One senses the rhythm of a repetition already, perhaps, of that ancient literary movement whereby – from Daniel to the popular books of Enoch or the Testament of Abraham – the so-called 'apocalyptic' text was always and necessarily imagined as having been mysteriously 'sealed up' for a period of time during which the text (retroactively, to be sure) 'waited' for those latter-day events and constellations which would conjure or effect its belated release, break its 'seals' as the authors of Daniel or Revelation liked to say.

Pasolini would write in his own *Tristram Shandy* of a novel, *Petrolio*, that the real question both of temporality and of causality is therefore, What codes eventually emerge into operativity, making events narratable, temporalized? Among other things, *Petrolio* can be read as a repetition of the quest to approach the codes or *schēmata* of and in the very appearing of narrativity, a quest on which linear temporal flows and coherent narrations of cause and effect often enough flounder or are inverted. Exploring the codes and conducts in question, a sort of editorial narrator intrudes onto a scene wherein *Petrolio*'s Carlo finds himself

3 See pp. 3, 4 above.

perusing objects in a used bookstore in Rome, an offscreen narration appearing, at the last, to add some additional notes as if for the improvement of a future edition of the account:

> Note in pen on a page of the Argonautica (Greek-English): 'Pay no attention! Every great writer writes only to fill the blank page with marks' and in smaller letters: 'Every great writer loves centones [patchworks of authorial scraps] above all. The culture of every great writer is medieval.'[4]

Such is the necessary scaffolding for, as it were, our Greek-Italian-English encounter with Pasolini's apostle as well, as if contingently appointed angelic messengers were unsealing temporalities decidedly out of joint, as if authors and origins were slipping into the void of a blank page on which are being scribbled medieval *centones*. Or perhaps the imagined substratum of the blank page of the *centone* must give way to an image of thought – and of time's contingent messengers – from latter-day technologies of cinematic bricolage or still later a digital cinematics. In any case, the structural effects are similar, these assemblages of agencies or agencies as assemblages leaving us stranded only ever to wonder about, so to speak, the software springing to operational life behind our screens. However we situate the screenplay, the audience of Pasolini's plan for a film about Paul encounters a decidedly scrambled temporality and a proliferation of unruly analogical mediators.

Naturally, just like all those apocalyptic authors in this new-and-old movement of thought, here we too will have necessarily played something like a willing pseudepigraphic role in the restaging of a piece that never really was, our own roles bearing more

4 Pier Paolo Pasolini, *Petrolio*, trans. Ann Goldstein (London: Secker and Warburg, 1997), 74. Pasolini's note about the handling of *Petrolio* (1973) suggests it was underway while he was also working on the screenplay about Paul (1968–72).

directly than is usually the case all those structures of an authorial, directorial fiction. We will have written, will have staged *as if* – above all, *as if* – there were no alternatives to the ironic trickeries and spatio-temporal displacements of identity and their causes which constitute the eventualities of our (inevitably Greek-Italian-English) project. With this evocation of an ancient and returned pseudepigraphic, apocalyptic staging in mind, let us play out the rules of the ancient genre by enacting a temporal collage which itself seems to summon so naturally a host of angelic or virtual testimonies, as if another angelic testimony were for us as well the primary staging device by which any illumination, the very light of *apokalypsis*, might arrive.

RECUPERATING ANGELS

> These figures have become exemplary for you, as if written for your rumination, on whom time's ends have come. (1 Cor. 10:11)

In a rhapsodic retrospective analysis of the rise of biopolitical immanence – which he glosses nicely as an emergence of an economy which calculates on 'the soul at work' – Franco 'Bifo' Berardi reflects on Italian critical theory in the 1960s and 1970s, particularly a moment Berardi associates with 1968 and a realization that

> social composition and the formation of revolutionary subjectivity can be explained neither by the idealist hypostasis of a human nature to be realized through historical action nor by the analysis of the implicit contradiction in the structure of productive relations. Neither the presupposition of a humanity needing to be redeemed, nor the analysis of capital are sufficient to understand what happens on the scene of twentieth-century history, on the stage of working class struggles and of capital's restructuring.[5]

5 Franco 'Bifo' Berardi, *The Soul at Work: From Alienation to Autonomy*,

Afterword 115

The formulation is part of Berardi's compelling retrospective rumination on the emergence of economies which seemed, increasingly, to have co-opted or to have functionally incorporated some of the collective identities or cultural logics which, prior to this point, had seemed to afford a relatively stable ground outside these economies or (which comes down to the same thing) a relatively fixed end toward which these economies tended.[6] In this respect, Berardi

trans. Francesca Cadel and Giuseppina Mecchia (Los Angeles: Semiotext(e), 2007), 59. As part of the analogical/apocalyptic play of figures and frameworks, it is worth pointing out that Berardi's articulation of this emergence of a new economy of desiring production in the late 1960s and 1970s was itself marked by a return of Italian theorists during this period to the Marx of the *Grundrisse*. It is worth wondering whether there is a developing *intensification* of a Marxian problematic which governs the way critical theory has been *increasingly* haunted by the spectral return of Paulinism, from the dialectically understood Paul of the Tübingen School during the writing of Marx's *Grundrisse* to Pasolini's Paul at a moment of 'return' to the *Grundrisse*, to an explosion of competing theoretical Paulinisms (e.g., Jacob Taubes, Alain Badiou, Giorgio Agamben, Slavoj Žižek) at a moment when the dialectical poles become more decidedly indistinguishable or 'negative'. While a great deal needs to be done, Roland Boer has more than anyone else diagnosed the mutually implicated trajectories of Marxist and biblical scholarship. See his twin books, *Criticism of Heaven* (London: Haymarket Books, 2009) and *Criticism of Religion* (London: Haymarket Books, 2011), as well as *Political Myth* (Durham, NC: Duke University Press, 2009). For more of a focus on contemporary ideology criticism, see also James Crossley, *Jesus in an Age of Neoliberalism: Quests, Scholarship and Ideology* (London: Equinox, 2012) or the philosophically focused story of nineteenth- and early twentieth-century biblical scholarship in Ward Blanton, *Displacing Christian Origins: Philosophy, Secularity, and the New Testament* (Chicago: University of Chicago Press, 2007).

6 Berardi's own work, of course, emerges from within a vibrant and developing tradition of Italian critical theory for which the diagnosis of these decades and their ongoing political significance is both essential and contested. A fuller contextualization of these texts, Pasolini's and Berardi's, within a specifically Italian critical theory (or, by the same token, a specifically Italian film history) is not my aim at the present, in part because my work is focused on the first-century *Greek* pole of my analogical Greek-Italian-English story

proclaims the slow fading into oblivion or communal obsolescence of two sites from which to imagine the launch of emancipatory cultural critique. When a 'presupposition of a humanity needing to be redeemed' or indeed the struggle for recognition *within* a pan-logicism of market calculation start to become beliefs or operations whose time has passed, then a belief in a new epoch of power relations announces its arrival, one which signals in turn the necessity for new exemplars of transformation, resistance, and solidarity. In ways at least comparable to the diverse work of Mario Tronti, Antonio Negri, Paolo Virno, Giorgio Agamben, Roberto Esposito, and Michael Hardt, here Berardi's retrospective also gambles on the possibility that the newly invasive or relatively more totalizing and immanent mode of economic calculations will yield new forms of significance for productive bodies imagined as singularities.[7] Herald of new forms of life, Berardi's analysis calls for a rethinking of soulish passion or singularity, a *topos* which comes to appear in this conceptual economy as neither a human factor to be imagined in an external relation to the power of capital nor as a self-enclosed identity in the name of which one could suspend the permanent revolution of capitalism for the sake of stable recognitions and proprietary limits therein.

of the screenplay (above), a comparative pole which is still underdeveloped even amidst the high profile 'return' of Paulinism as a comparative touchstone for philosophy and critical theory. Nevertheless, without suggesting 'to cover' this side of the comparative story, for those interested, one should mention (in addition to studies I discuss below), at least two efforts to situate and present the larger theoretical debates, Michael Hardt and Paolo Virno, eds, *Radical Political Thought in Italy: a Potential Politics* (Minneapolis: University of Minnesota Press, 2006); Lorenzo Chiesa and Alberto Toscano, eds, *The Italian Difference: Between Nihilism and Politics* (Melbourne: re.press, 2009).

7 Rather than expanding the list of Italianists obsessed with questions of biopolitics, I will simply mention here the attempt at a synthesis in Andrea Righi, *Biopolitics and Social Change in Italy: From Gramsci to Pasolini to Negri* (New York: Palgrave, 2011).

Berardi, with his retrospective bidding adieu to earlier modes of critical theory, is an important interpretive messenger, so to speak, for our figuration of Pasolini's screenplay about Paul, on which Pasolini worked between 1968 and 1974. After all, Pasolini's piece is, from start to finish and from draft to draft, plagued by the question of desiring production, particularly as it constitutes constellations of desire, freedom, and the frames or regulating institutions whereby desire intersects with forms of speech and recognition. In this respect, the *apokalypseis* or revelations of Pasolini's Paul are integrally tied to Pasolini's brilliantly anachronistic placement of the apostle between fascist power of the late 1930s and what Pasolini often described as an epoch of permissive power or repressive tolerance emerging in the late 1960s. Situating the apostle of a law-free evangel of liberty between epochs of fascism and consumerism itself demands further reflection on that political question which spurs important interventions throughout Pasolini's writings (for example *Lutheran Letters*, *Heretical Empiricism*) and his films (*Love Meetings*, *Salò*), namely: does the transition from a repressive Oedipal economy to an economy of relations named by the consumerist incitement to desire and enjoyment actually accomplish, socially speaking, a political form of control which a repressive fascism itself could never accomplish?[8]

Echoing Berardi's analysis, for the Pasolini of the late 1960s and early 1970s, it was as if crucial sites of ostensibly transgressive desire had themselves become installed as integral mechanisms in a feedback loop constituting a much more invasive and effective economy of control and, as Pasolini liked to say, normalization. In a prescient wonder comparable to that which drove Michel

8 As we will see, I read Pasolini's moves against the backdrop of rich comparative discussions of 'Oedipus' in Paris. For an important evaluation of this period, see Miriam Leonard, *Athens in Paris: Ancient Greece and the Political in Postwar French Thought* (Oxford, UK: Oxford University Press, 2005). I am indebted to Michael Dillon for making me aware of this work.

Foucault's early work on the history of sexuality or Jean Baudrillard's early diagnoses of the consumerism of mass media's sexual imaginary, Pasolini famously noted his own anxieties in the shifting cinematic significance of the represented sexual body. Evoking a recurrent phallic terminology in his essay 'Tetis', he writes:

> Even though, in *The Arabian Nights*, and also in the next film [*Salò*] which will have 'ideology' as its explicit theme, I will continue to represent *even* physical reality and its blazon, Tetis, I *regret* the liberalizing influence that my films have contributed, in practice, to a *false* liberalization, actually desired by the new reformist and permissive power, which is also the most fascist power in history.[9]

Foreshadowing Berardi's anxieties about the incorporation of resistance and earlier struggles for recognition into the rhythms and algorithms of capitalism, Pasolini goes on to describe uncertainties about whether, with 'the last years of the sixties', the political gamble on 'the body' as 'the only preserved reality' in relation to capitalist normalization or governmentality itself was not giving way to a suspicion that the erotic body was caught up in a machinery of normalization feeding directly into the ritual maintenance of new identities even better adapted to a 'neocapitalist' or consumerist economy.[10]

As if by some impishly perverse agency, even the new thresholds to which Pasolini himself had brought Italian cinema seemed to him to have collapsed into a mere simulacrum of transgressive resistance to normalization. Pasolini here points repeatedly to his successful release of a cinematic image of a 'sexual organ in detail

9 Pier Paolo Pasolini, 'Tetis' in Patrick Rumble and Bart Testa, eds, *Pier Paolo Pasolini: Contemporary Perspectives* (Toronto: University of Toronto Press, 1994), 248.

10 Ibid., 246.

and close-up', an evental cinematic threshold which constitutes, by any measure, a new limit of scandalizing representation, or at any rate an 'enormous cock on the screen'.[11] But this transgressive breakthrough in the struggle for the representation of the desiring body had begun to signify for Pasolini only the flame of a potlatch ceremony, precisely the *destruction* of a transformative excess, its *sacrifice* rather than its emancipatory conjuration into presence.

This image is an important one for our constellation of apocalyptic signs and apostolic narrations, one we should keep in mind when we recall Pasolini's Paul stranded between 1938 and 1968. Pasolini is awkwardly clear on this point, claiming in his statements about sexual imagery in cinema that, both sexually and politically speaking, the rebels of the latter regime of power are anything but what they appear: 'Today, the youth are nothing but monstrous and "primitive" masks of a new sort of initiation (negative in pretence only) into the consumerist ritual'.[12] Indeed, picking up on Pasolini's suggestion that this experience of his own work pushed him toward cinematic presentations of sex with ' "ideology" as its explicit theme', it is noteworthy that he foreshadows *Salò* in such a light, namely, as a fascism which is indistinguishable from a brutal command to enjoy. As Andrea Righi remarks on the film as part of his genealogy of biopolitics:

> Pasolini's use of sexuality in *Salò* is crucial to understanding the consequences of this false idea of freedom. In consumer society, individuals are at the same time victims and victimizers; they take advantage and are simultaneously exploited by a system that is based on an endless cycle of production and consumption.[13]

11 Ibid., 246–7.

12 Ibid., 246.

13 Righi *Biopolitics and Social Change in Italy*, 89. We should note also the research of Naomi Greene, whose work articulates *Salò* against the backdrop of consumerist 'neocapitalism' and describes the way many of Pasolini's

Such certainly seems to have been Pasolini's apocalyptic or catastrophically inverted diagnosis, and it is here – situated by a demand to understand a relatively more seamless economy of production and consumption – that the filmmaker and critical cultural theorist sets to work the conjuration of an ambiguous return of the Pauline legacy. In the late 1960s and early 1970s, these and similar diagnoses of a harrowing transformation of the ontologies of power and resistance began to circulate throughout Europe as if a climate change were beginning to be registered. The sensitive were charting similar alterations in temperature within Paris, for example, and in ways that constitute an intriguing further context within which to articulate the emergence of Pasolini's Paul. It was in his seminar of 1969–70 that Jacques Lacan began with a rather astonishing statement, one clearly directed against popular understandings of May 1968 and its aftermath:

> What analysis shows, if it shows anything at all ... is very precisely the fact that we don't ever transgress. Sneaking around is not transgressing. Seeing a door half-open is not the same as going through it. We shall have the occasion to come back to what I am introducing now – there is no transgression here, but

contemporaries resisted this reading, interestingly, preferring to find instead a confessional Pasolini making clear that he hated his own sexuality along with many of his critics. She writes:

> In *Salò*, sexual acts are totally brutal and without preamble; its victims do not undress but appear nude, lined up as if waiting for the gas chambers. In this sexual lager, no real *jouissance* is possible. Its tortured victims bear no resemblance to the heroines of a certain pornographic tradition who achieve pleasure through pain. And even their executioners, that is, the libertines, do not attain the pleasure they so endlessly seek. Meticulous bureaucrats, banal torturers, Pasolini's libertines are driven not by the energy or the pulsing of desire but by impotence and frustration.

Naomi Greene, '*Salò:* the Refusal to Consume', in Rumble and Testa, eds, *Pier Paolo Pasolini: Contemporary Perspectives*, 234f.

rather an irruption, a falling into a field, of something not unlike *jouissance* — a surplus.[14]

This evocation of a discursive world without transgression marks a subtle shift in Lacan's thinking about power, even as it opens a new lecture series which developed some of Lacan's most compelling insights about the castration, lack, or non-existence of the big Other as the final frame or guarantee for judgements about power relations.

Reconfiguring earlier diagnostics in light of what he often describes as a kind of 'experience' of newly emerging cultural logics, it is here on the 'other side of psychoanalysis' that Lacan diagnosed an oddly *ambivalent* supplementation of the lost Other, that lost Cause in relation to which we might desire 'to be submitted', as Paul says in the citation that begins this essay: 'Tell me, those wanting to be submitted to law, do you not listen to the law?' Whether or not we would hope to be so submitted in order to ground antagonism and rebellion or obedient compliance would make little difference. In either case, the big Other's non-existence itself abandons both would-be transgressors and rebellious revolutionaries alike to a difficult necessity of rethinking the very nature of desire in relation to cultural or symbolic authority. The transgressively desiring body, to recall Pasolini, is here in Lacan's analysis no more a 'preserved reality' outside of the structures of power than it was in the later writings of the filmmaker. In Lacan's discussion of a freedom now difficult to conceptualize or place, we are forced to manage an excessive weight of the immanence of desire in its relation to a merely virtual big Other. We are forced to manage the weight of this relation precisely because we do so without the shelter or justification of a

14 Jacques Lacan, *The Other Side of Psychoanalysis: The Seminar of Jacques Lacan, Book XVII*, trans. Russell Grigg (New York: W. W. Norton and Company, 2007), 19f.

belief that the law, the father, or the repressive regimes of money or power exist, precisely, apart from this ritualized investment in them. In such a scenario, it is structurally impossible to distinguish transgressive desire from Pasolini's ' "primitive" masks' donned for a ritual through which we would have conjured the presence of the Other in question. Without eliding genuine antagonisms between the different theorists, the same *problem of desire* (which is to say a very similar 'problem of the law'), as an awareness of the structural or economic ambiguity of transgression, marks also other watershed contributions which emerged at the same moment in the work of Gilles Deleuze and Félix Guattari (*Anti-Oedipus*, 1972), Jean-Francois Lyotard (*Libidinal Economy*, 1974), Jacques Derrida (*Dissemination*, 1972), and Jean Baudrillard (*The Consumer Society*, 1970).

THE ANCIENT PAUL IN AN OPEN ECONOMY OF SURPLUS VALUES

It is worth reflecting on the way that the Paulinism of Jacques Lacan, so to speak, has often been associated with his interest, during the earlier 1959–60 seminar, with Paul's text of Romans 7, as well as a form of thinking which has shifted in slight but important ways by the time of his lectures on 'the other side of psychoanalysis' ten years later. Recall that in the ancient text of Paul, the apostle imagines an economy whereby a perverse mode of power operates behind the back of an otherwise docile or submissive imaginary self, this hidden operation functioning to effect the self's problematic splitting or doubling. Interestingly, Paul was likely playing out this splitting of the subject by appropriating the theatrical tableau of Medea, whose desire to act violently against other impulses within her became a favoured touchstone for Hellenistic and especially Roman philosophical diagnoses of the 'problem of passion', which Paul here articulates as a

problem of law or of juridical authority.[15] It is in this mode that Paul writes in Rom. 7:21–4:

> So I find it to be a law that when I want to do what is good, evil lies close at hand. For I delight in the law of God in my inmost self, but I see in my members another law at war with the law of my mind, making me captive to the law of sin that dwells in my members. Abject person that I am! Who will rescue me from this body of death?

Obscuring the way Paul maps his discussion onto Roman philosophical discourse, a long history of Christian readings of this peculiar passage about law's production of transgression has oriented itself by a supersessionist narrative of Christianity's triumph over Judaism. This reading, of course, unhelpfully imagines that what were in actuality Paul's partisan Jewish interventions *within* a vibrantly diverse first-century Judaism constituted something like a 'Christian' *break* with Judaism. As Paul never called himself a Christian and would have refused the supersessionist implications of such a terminological distinction, neither the terminology nor the teleologies underlying this traditional narrative prove

15 While they disagree profoundly about the way Paul interacts with Hellenistic philosophical traditions, several crucial touchstones must be mentioned here: Stanley Stowers, *A Rereading of Romans: Justice, Jews and Gentiles* (New Haven, CT: Yale University Press, 1997); Dale B. Martin, *The Corinthian Body* (New Haven, CT: Yale University Press, 1999); Troels Engberg-Pedersen, *Paul and the Stoics* (London: T&T Clark, 2000), and Engberg-Pedersen, *Cosmology and Self in the Apostle Paul* (Oxford, UK: Oxford University Press, 2010); Emma Wasserman, *The Death of the Soul in Romans 7: Sin, Death, and the Law in Light of Hellenistic Moral Psychology* (Tübingen: Mohr Siebeck, 2008); George Van Kooten, *Paul's Anthropology in Context* (Tübingen: Mohr Siebeck, 2008); Niko Huttunen, *Paul and Epictetus on Law: A Comparison* (London: T&T Clark, 2009); Runar Thorsteinsson, *Roman Christianity and Roman Stoicism: A Comparative Study of Ancient Morality* (London: Oxford University Press, 2010).

illuminating for contemporary encounters with Paul. Nevertheless, this traditional orientation has often functioned very effectively to exclude all other modes of thinking about ancient or (by analogy) contemporary identity in relation to prohibition, or about the plurality and limits of different legal codes, none of which are topics that are far from ancient discourses on *nomos* or law, or irrelevant for latter-day reflections on power.[16]

For our purposes, it is useful to allow Romans 7 to operate as a machine with which to think through the problem Righi articulates: the idea of a consumer society economy, in which the producer/consumer is *simultaneously* victim and victimizer, and this because of a capacity – as Paul put it – 'to seize a chance opportunity [cf. *aphormēn de labousa*]' (Rom. 7:8) to create a surplus desire or excess of relation within the otherwise fixed poles of the juridical scene. As we will see, this comparative constellation articulates an impish mode whereby an open economy of power relations can be formulated (both hopefully and also perhaps darkly) as the possibility for any of its moments to be subtracted from the dominant form of structured power, a possibility which already may suggest that the form of power itself *only* emerges retroactively. Or, to evoke the initial statement of Deleuze above, it is only through the vanishing or withdrawal of an open operation of the production of exceptionality or surplus that power is itself retroactively constituted. Paul's quirky articulation of what is traditionally named as the theologico-political 'problem of the law' in Romans 7 emerges hand in hand with an epoch in which capitalist power as production of surplus operates at once expansionistically but also eventually, as an event or an emergent production of surplus

16 For further discussion, see my introduction, 'Back to the New Archive', in Ward Blanton and Hent de Vries, eds, *Paul and the Philosophers* (New York: Fordham University Press, 2013), or the opening salvos in Ward Blanton, *A Materialism for the Masses: Paul the Apostle and Other Partisans of Undying Life* (New York: Columbia University Press, 2013).

relationalities – an eventalism that deforms earlier models of cause and effect.

In the text of Romans, notice the way in which the dialectical standstill or suspension of agency within the juridical economy does not simply operate in the splitting or doubling of the inner man/wretched man of this scene, thus fissuring his agency into antagonistic strategists (Rom. cf. 7:21–4). Much more striking than this Platonic splitting of agencies, I think, is the way that law (*nomos*) can clearly be seen to be a matching split or duplication, as if the agency of itself (*nomos*) appears as *both* prohibition *and* transgression of the same. Inherent in this passage is a sense of a 'law' of law itself, as if having 'discovered' a law within law or a code inside of code, the chance of a little shadow of law capable of producing its opposite, manufacturing resistance to the same, active rebellion and criminality rather than docile acquiescence to appropriate limitations. 'So I find this law: when I want to do the good, evil lies ready to hand … [That is] I see in my members another law [*heteron nomon*] at war with the law of my mind [*nous*]' (Rom. 7:21f.). Here the very impasse or obstruction within the otherwise smooth functioning of power in a system of juridical compliance itself comes to name *another nomos*, namely, the *nomos* of the manner in which the arrival of the commandment is a repetition of the 'springing to life again of sin' (Rom. cf. 7:9). Throwing off the rails a Platonic imaginary wherein the interiority of the mind or *nous* affectionately mirrors the divinity and goodness of 'law', here the repressed returns as 'another law' which irreparably disrupts the stability of an economy of law even as it displaces the 'I' from itself, effectively 'killing' it (cf. 7.10). Most importantly, this very displacement and splitting of the I itself emerges from a 'chance' which is susceptible of being grasped as a 'production' (cf. *kateirgasato* 7.8) of a surplus, this seizure of chance being the open source underwriting the inversion of the value of the intentions of the actors here in question. As if revealed from heretofore

nonexistent angelic mediators, here the 'problem of law' as the 'problem of passion' appears with real clarity at the moment when neo-capitalist modes of the production of surplus value and the structured recuperation of transgression seem, precisely, to constitute the political ontology within which we live, move, and have our being.

THE CAPITALIZATION OF MASTERY, OR, THE SHADOWY DOUBLE OF LAW

It is this little shadow of law, this excessive surplus within law, that effects in this intriguing passage a doubling and self-suspension of juridical authority as an imagined form of emancipation.[17] Elsewhere in his writings, Paul, playing the role of overheated partisan, seems much more comfortable than he does in Romans 7 with presenting the juridical economy of *nomos* solely as an agency of enslavement or as an apparatus for the production of transgressors. One could certainly wonder on reading his letter to the Galatians, for example, whether Paul imagined the juridical economy to found itself *only* by way of the manufacture of

17 We should note immediately that discourses about *nomos* in ancient Mediterranean contexts afforded a panoply of modes by which to double, and effectively circumvent, sublimate, or negate the value of a particular instance of *nomos*. Philosophers, of course, often switched codes from ethnic to natural law, precisely to allow the doubling and displacement of *nomos* as a mode of escaping the effective operation of the local or the allegedly general. Jewish traditions, from Josephus to Philo to the texts of the Dead Sea Scrolls, perform similar operations, sometimes adding additional tricks about the (oral or written) media of nomological discourse. In a word, in moments like these, Paul inhabits, rather than subtracts himself from, Jewish and philosophical traditions alike. Two very important efforts to locate Pauline discussions of *nomos* within their general Greco-Roman environments are Brigitte Kahl, *Galatians Re-imagined: Reading with the Eyes of the Vanquished* (Minneapolis: Fortress, 2010), and Davina Lopez, *Apostle to the Conquered: Re-imagining Paul's Mission* (Minneapolis: Fortress, 2010).

criminality as the exception to juridical norms (see Gal. 3:10–13, 19, 22; 4:3, 9.). In the later letter to the Romans, however, Paul seems more intent on supplementing the otherwise short-circuited, suspended, or exhausted polarities of agency into which, for Paul, the juridical economy seems to have fallen. Indeed, note just how in the Romans text 'sin' is relied upon as a crucial supplementary agent. This 'third' agency is being imagined as the localizing *cause* of the displacements of activity and passivity within the otherwise short-circuited functioning of juridical economy. In what many commentators over the centuries have imagined as a kind of response to possible views of Paulinism emerging from the more trenchant earlier letter to the Galatians, Paul presents a virtual conversation with an interlocutor who asks: 'So what are we saying, that the law is sin?' To which Paul responds: No! Rather, it is *sin* which 'seizes an opportunity' within *nomos*, this extra-legal act of partisanal warfare itself yielding the perversely split (and perhaps Medean) scenario described in the seventh chapter of Romans.

Perhaps despite Paul's efforts to stabilize the otherwise destabilized juridical economy by way of the naming of 'sin' as a supplemental agency, the nameable *cause* of disturbance, the *function* of the agency of sin within this Pauline tableau is very simply the function of the power of exception-making through a potentially productive surplus and its appropriation, which displaces the status of otherwise perceived labouring roles. In this respect, 'sin' is simply the retroactive appendage of the 'chance opportunity' itself, the agent that is the effect of a more primordial zone from which arises the potential for partisan co-optations, rogue attacks, and potentially revolutionary emancipations. It is no accident that in this passage Paul appropriates the favoured lingo of 'seizing a chance' from, among other places, a panoply of Greek texts about military history. Random occurrences, chance encounters, enable the polemically inclined to 'seize' or 'take' the opportunity afforded by chance, transforming the nature of sovereignty in a

kairological moment of opportunity which opens onto new orders of structured power. The seizure of chance in these texts constitutes a kind of Schmittian act of appropriation, though one not merely at the disposal of regnant powers.

On the contrary, in many cases regnant power must maintain itself by immunizing itself against the arrival of these unformed moments of chance. As the first-century Jewish historian puts it, much more effective than defeating one's political enemies is to immure the current situation of power against the 'chance' (*aphormē*) of viable contest in the first place.[18] Paul's exposition of works and the weaponization of surplus against would-be workers fits such descriptions exactly. Note, for example, that Paul's scene here emerges against the backdrop of a lack of power in law – he names its status as *adunaton* – opening the way to understanding the productive economy of commandment as one constituted through an originary 'weakness' or inoperativity within the (active, sovereign) law and (passive, docile) flesh pairing (cf. Rom. 8:3, *to gar adunaton tou nomou en hō ēsthenei dia tēs sarkos*).

It is only at first glance, therefore, that Paul's tale seems to side with traditional sovereignty, as if bemoaning the weakness of effective order, and longing for a moment when the role of *nomos* in a representational economy of commandment could be stabilized. Many commentators, docile sorts themselves perhaps, assume that Paul *merely* laments the deformation of the sovereign command of *nomos* at the hands of the radical partisanship and the interventionism of 'sin'. But this is to miss the implications of the way Paul has here made sin, properly speaking, a post-representational and insurrectionist partisan – what Paul himself calls (in a line of great interest to Jacques Lacan and George Bataille) sin's manifestation through the (inoperativity or surplus activity of the) commandment as 'sin beyond measure' (*hina genētai*

18 Josephus, *Antiquities* 2.239.1.

kath' huperbolēn hamartōlos hē hamartia dia tēs diathēkēs). Here it is crucial to pay attention to the specific modes in which Paul maps his discussions of sin's partisanship onto the seizure-of-chance motif, a motif which was never, in the ancient Mediterranean contexts, *simply* about the anxiety of the powerful to immunize their situation against it. Seizing the *aphormēn* or chance was also, we must never forget, about the capacity for transformative insurrections, a discourse of partisans without acceptable political representation, none of which was far from the advocate of a brutally murdered messianic figure.

When Jacob Taubes intervened in the political history of Pauline reception in order to develop a genealogical subversion of the dictatorial exceptionalism of Carl Schmitt, Taubes looked to Paulinism as a mode of attending to transformative contingency or the (as if *ex nihilo*) *surprise* and openness of transformative sovereignty, just as Schmitt did. But Paulinism, Taubes argued, enables a way of attending to the same rogue contingency 'from below' rather than from the position of Schmittian institutions or dictators which often (and at the worst moments) marked Schmitt's analysis. Taubes's important intervention nevertheless did not pick up on some of the crucial aspects of Romans 7, including the rather astonishingly inverted Schmittianism we might find in Paul's use here of Schmitt's beloved theological term of the *katechon*, or 'suppressive' capacity of power.[19] At Romans 7:6, for example, it is through the community's adamant identification with the criminalized and effectively suppressed messianic figure that they 'have died' to the effective grasp of *nomos* generally. The Paulinist insurgency of the crucified is described as excepting itself from the juridical economy, their having subtracted themselves from the effective force which, Paul writes, 'suppressed them' (*nuni de katērgēthēmen apo tou nomou apothanontes en hō kateichometha...*). Far from

19 Jacob Taubes, *The Political Theology of Paul* (Stanford, CA: Stanford University Press, 2004).

Schmitt's usual katechontic or suppressive power of constituted rule against threatening chaos, in Paul it is the implacable dissidents doggedly identifying with a failed emancipatory movement who have, with that perverse identification, subtracted themselves from the *suppressive power* of the legal order against them.

Far from being a 'Christian' break from Judaism, here Paul's rhetoric is in keeping with a rich and diverse tradition of early Jewish partisanship and contestation of inherited norms of all sorts. Note, for example, that the first century commentator and philosopher Philo of Alexandria could also imagine that a divine law installs within itself the *aphormē*, as if Philo, too, were reflecting on the possibility of a divinely sanctioned chance (chance as divine sanction) for the deformation of identity, causality, and the economy of commandment. Thus, Philo writes, in legal traditions of scripture, strangers are given a 'chance' or opportunity to appropriate legally those goods and rights which were not officially or originally afforded them because of their identity as outsiders (cf. *Special Laws* 2.118.2). Philo also narrates key moments in the surprising scriptural deformation or revolutionary transformation of the identity of the people by way of the terminology of chance, as when a non-Israelite prostitute becomes the crucial bearer of the people's legacy, indeed the very 'origin' of their justly constituted *polis* (cf. *On the Virtues* 222.6). Similarly, identifying with the partisan against repressive power structures, Josephus, too, understands that what was the ostensible *destiny* of Moses (to be the cause of both the downfall of the Egyptians and an emancipatory exodus of the Israelites) nevertheless had to occur in a moment of chance openness to transformation (namely, the invasion of Egypt by the Ethiopians). Josephus' Moses, just like Paul's sin, effects the transformation of agencies, territories and sovereignties by 'seizing the opportunity', both writers appropriating the same Greek terminology of sovereignty and partisanship (cf. *Antiquities of the Jews* 2.239.1).

In other words, the 'seizure of chance' is itself the unformed, deforming moment in the economy of identity, sovereignty, and commandment whereby radical transformation may be effected. Or, as I have already intimated, one might even say that the drama of divinity in these ancient texts is *nothing but an attentiveness to this open space of transformation*, almost a monotheistic variation of the question of causality and openness which the polytheistic traditions deified as *tuchē* or chance. After all, the potential seizure of chance is at once imagined as both the origin and possible revolution of modes of life, the singular aura or surplus value of which has always been the stuff of religion.

Importantly, however, the seizure of chance is not simply a militaristic or revolutionary category. Genealogically, philosophically, there is simply chance to be grasped, the act itself enabled by an allowance or fund by which one insinuates one's own stance into the stream, say, of philosophical ideas. As he trots out one after another philosophical argument in order to seize them all by an indifferent middle wherein his scepticism finds an uneasy resting place, Sextus Empiricus articulates Zeno of Citium in the same way that Paul articulates 'sin' as a subversion of nomological hierarchy: 'And Zeno of Citium, taking Xenophon as a point of insertion (*apo Zenophōntos tēn aphormēn labōn*), says that …' (*Against the Physicists*, 101). Zeno here grasps Xenophon as his opportunity, his mode of self-insinuation, his starting point, and he does so through the same language as sin in Paul's text about a doubled and subverted legal order. Xenophon, in providing the capitalizing fund of a chance opportunity or openness to intervention, appears here citationally. Zeno starts with a quotation from another, this move of the other opening a way for someone else to take up residence therein, indeed, to steer the whole conversation differently. After all, in this passage, the chance *aphormē* is a citational 'starting point' of another, the other as a 'base of operations' for some other project to take root in. It is unfortunate that, in our

genealogical lineages and family trees of ideas and political traditions, we tend not to see the immediate associations of a figure like Paul with the radical sceptical *epochē* or, in a latter-day instance, the everyday subversions of such gestures in Deleuze's Lacan or Sacher-Masoch. To add one further genealogical twist, we might even say that, in keeping with another of the ancient meanings of seizable *aphormē*, in Paul's confounding of the efficacy of *nomos* by way of the 'chance opportunity' of this economy's inversion, we have a witness to that *'capital' which funded* both the promise and the debts of ancient religiosity, the surplus value or excessive forcefulness of its stability *and* its openness to radical transformation.[20]

In light of this ancient discourse, it is worth remembering Pasolini's sense (discussed above) of a catastrophe at work in the inversion of an image of cinematic rebellion into a form of normalizing participation within a more diffuse and consumerist political economy. It is worth thinking, in other words, that whether one intends to fulfil the law or to transgress it, there is 'another law' in excess of law capable of subverting both intentions. Both moments of relating to the juridical or representational capacities of a 'code' are traversed by a monstrous opening whereby a kairological chance apparently could be 'seized' at any moment, and it would make little difference whether this seizure renders the obedient as transgressors or the transgressive the new obedient. Perhaps someday we will understand that Paulinism has always been part of that archive of contingencies, partisanships, and their always contingently discovered 'laws'. What else is that partisan Paul's own seizing upon what could otherwise no doubt *only* be read as the effective operation of imperial juridical power, namely, a Roman crucifixion of yet another serial messianic figure within

20 Ancient discussions assumed that the fund of *aphormē* could be borrowed, saved, and form the origination of new enterprises (cf. Xenophon, *Memorabilia* 2.7.12; 3.12.4), or even the distributed fund of the state itself (cf. Aristotle, *Politics* 6.1320a39).

first-century Jewish culture? As discussed above, Paul latched onto the suppressed aspect of his messianic figure in a way that can only be described as doggedly obsessive: 'I intended to know nothing among you except Jesus Christ, and this one *as crucified* [*kai touton estaurōmenon*]' (1 Cor. 2:2). Or, in that inimitable style of the Paulinist partisan: 'You stupid Galatians! Who has cast a spell on you, before whose eyes Jesus Christ was clearly performed *as crucified*!' (Gal. 3:1).

Remember that we should hesitate before we retroject later Jewish and Christian rationalizations of Paul's seizure of *this* (to say the least, rather unpromising) 'chance opportunity'. Paul's appropriations of a messianic figure who was both humiliated and executed by occupying forces was much more interventionist, fragmentary, and surprisingly open-ended than these later justifications (and often enough co-optations) recognize. In so hesitating to allow latter-day ideologues to rewrite the hesitating, risky performance of the earlier moment, we are more likely to attend to the modes in which Paul and his cohort struggled, essentially, to fold the effective operation of imperial power back onto itself, as if to hollow out a bubble of unsurveilled powerlessness within effective power itself. ('No way will I ever boast except in the cross of our lord, Jesus Christ, through which the world has been crucified to me, and me to the world' (Gal. 6:14); 'But if we have died with Christ, we believe that we will also live with him ... Consider yourselves dead ... but alive' (Rom. 6:8, 11). In dying to law by their dogged identification with the crucified, Paul claimed that the believers had been subtracted from the suppressive or katechontic power of the juridical order.

To put the matter differently, was not the secret of Paulinism already that his own *kairos* or now-time of a surprising event (cf. Rom. 5:6; 9:9; 13:11), the moment which for him constituted the transformative power of a new age, was precisely in keeping with (or formally the same as) the operation of sin's 'seizing an

opportunity'? This is the case despite the way that Paul likewise attributes to the aleatory or supplemental forcefulness of a chance perversion of efficacy within 'the commandment', a structure of agency or causality by invoking the name 'sin'. Put more dramatically, we should not be misled by the ostensibly gut-wrenching, soul-searching rhetoric of a split subject: 'Who will rescue me from my split subjectivity?' (cf. Rom. 7:14–25). After all, it was only because Paul's catastrophically criminalized Christ was taken by the apostle as the messiah's having 'been made sin for us' that Paul was to have anything ostensibly emancipatory to say about his Christ at all (cf. 2 Cor. 5:16–19; 21). It was this suppressed messiah which was for him the exemplary clue that the merely believing may 'become' outside the economy of the manufacture of representative transgressors. It was, in other words, not only sin which seemed to have learned the affinity between partisanship, transformation, and seizing on a subversive chance. If the *nomos* of the current order makes transgressors of you, you might consider how transgression itself speaks doubly as the end of transgression, even as a kind of redemption to be seized upon.

My assertion is that it is the very topic of a free-floating surplus of production within the economy of power relations which hovers above both the ancient Paul and his return in late capitalism. This is a genealogical puzzle whose effects remain to be worked through. Nevertheless, playing the good neo-Paulinist, Lacan was inviting his would-be revolutionary students to a similar mode of thought to that of Paul's, certainly no less perverse, rethinking the role of desire within machinations of power and resistance with implications we should not miss. For example, Gil Anidjar has given a very nice Schmittian reading of Paul, focused on Paul's politely diminutive question: 'In telling you the truth, have I become your enemy?' (Gal. 4:16).[21] As Jacob Taubes tried to do earlier, Anidjar

21 See Gil Anidjar, 'Freud's Jesus (Paul's War)', in Ward Blanton and Hent de Vries, eds, *Paul and the Philosophers* (New York: Fordham

here forges an important link between Paulinism and different types of Schmittian exceptionalism which have yet to be worked through in depth. Above all, we should note the many *modes* in which the *kairos*-obsessed partisan conjures an apostolic *polemos* from within inherited forms of habituated activity or from representative figures of the larger established communities. As Philo of Alexandria explores interestingly, inference or the taking of an interpretive tack within a tradition is a result of seizing upon the *aphormē* of a chance (cf. *Who Is the Heir of Divine Things?* [*Heres*, 300.3ff.]). In keeping with this standardly Jewish hermeneutic tradition, it is this partisanal tack whose inferences split, divide, and solicit the new and surprising (or, perhaps, the monstrous) which we see everywhere in Paul. Thus, in moments of Paul's polemic, becoming circumcised becomes, somehow, a 'cutting oneself off' from messianic benefit (cf. *katērgēthēte apo christou*); the beneficent father Abraham mutates into an anarchic 'father' of an impossibly generated people, genealogy replaced by an aggressively virtual form of lineage constituted, as it were, only 'before' the representations and stabilities law (cf. Gal. 5:4; 3:16–18, 29; 4:31). The Paulinist orgy of disproportion also raises its head when Paul

University Press, 2013). Several other comparative encounters with Pauline and Schmittian topics of the *katechon* or restrainer of political catastrophe may be found in the excellent work of Michael Dillon, 'Spectres of Biopolitcs: Eschatology, Katechon and Resistance', in *South Atlantic Quarterly*, vol. 110, no. 3, (Summer 2011); Sergei Prozorov, 'From *Katechon* to Intrigant: The Breakdown of the Post-Soviet *Nomos*', in Alexander Astrov, ed., *The Great Power (mis)Management: The Russian-Georgian War and Its Implications for the Global Order* (Surrey, UK: Ashgate, 2011), 25–42; and (implicitly, through his longer history of scholarship on Schmitt) Mika Ojakangas, 'Michel Foucault and the Enigmatic Origins of Bio-politics and Governmentality', in *History of the Human Sciences* vol. 25, no. 1 (2012), 1–14; and Michael Hoelzl, 'Before the Anti-Christ Is Revealed: On the Katechontic Structure of Messianic Time', in Arthur Bradley and Paul Fletcher, eds, *The Politics to Come: Power, Modernity and the Messianic* (London: Continuum, 2010), 98–110.

asserts that the aura of Moses shining down from Sinai was veiled, yes, but veiled only *because of an embarrassment about the fact that this shining 'glory' was already fading away* (cf. 2 Corinthians 3.12ff.). Like Lacan's Joyce, Paul the partisan repeats tradition while deforming it, deforms it while repeating it, following the singular declinations and inflections of the seizure of chance (and, as we have pointed out, in keeping with his Jewish hermeneutical contemporaries).[22] For the Paulinist, the messianic age as much as 'sin' was capable of 'seizing an opportunity', and this to turn agency and agencies against themselves, splitting their operations into conflictual multiplicities of identity and radically altering their capacity to maintain themselves as hegemonic forms of power in the process. Playing the role of a kind of 'sin without measure' in relation to the effective economies of 'commandment' constituting Roman imperial domination over the intractably rebellious Jews, for example, Paul declares that the Roman transformation of a would-be messiah into a form of stupidity and failure should itself be grasped as a moment of divine wisdom and triumph of the undying divinity of the partisan (cf. 1 Cor. 1), indeed a divinity which has given rise to a new 'city council' (*ekklēsia*) of the un-dead, a council consisting of those who act as if *already* dead so that they might live beyond the 'suppressive' economy of *nomos*. Carried away by the unending, undying life of this very gesture, Paul even boasts that if the 'rulers' knew what they were doing when they put down this messianic figure, they wouldn't have done it (1 Cor. 2:8). His point here is not simply that the rulers were 'mistaken' in their crucifixion of the rebel from Palestine. Much more in keeping with his argument is rather that in their very enactment of imperial control and legal condemnation of a

22 For an excellent discussion of the role of Joyce as exemplar of a quasi-emancipatory fidelity to one's (singular) symptom, see Lorenzo Chiesa, *Subjectivity and Otherness: A Philosophical Reading of Lacan* (Cambridge, MA: MIT Press, 2007), 188ff.

messianic figure from a dissident state, the 'rulers' became susceptible to the doubling, splitting, undying power of the divinity of emancipatory partisanship. Roman imperial power, too, knows not what it does, living as it does off of a surplus or excess which is only imagined to be owned.

The analogies between Paulinism and the 'problem of power' in the late 1960s are perhaps most vibrant when imagined as part of a pastiche of the multiplicity of modes in which 'seizures of chance' afford new modes of undoing the power of power, rendering ineffective the coding of codes, or reversing the value of effective history. In summary, it is in the generalization of the role of the 'partisan' with the unregulatable development of 'neocapitalist' economies that solicits a 'return' of Paul and of all those *topoi* of life inhering in death, a decree of salvation attaching to the imperial condemnation of a criminal, and so forth. As a figure of thought and analogical provocation, Paul returns as a peculiarly forceful touchstone within an economy whereby we are all subjects of, and subject to, the capacity to 'seize on a chance opportunity' in order to destabilize the very force of normativity.

CONCLUSION: SEIZURES OF CHANCE, OR, THE CAPITALIZATION OF MASTERY

As one last angelic/analogical testimony, one last witness for the illumination of Pasolini's Paul, note how Lacan's 1969–70 lecture course mentioned above signals a subtle rewiring of Lacan's earlier statements about the authority of law in relation to transgression, say, in his seminar on the ethics of psychoanalysis (1959–60). In the earlier lectures, Lacan's attention was not so much on the economies whereby transgressive *jouissance* feeds back into structures of authority and control, though the implication is already there, but rather on the modes whereby *jouissance only* appears as such in relation to its prohibitive opposite:

We are, in fact, led to the point where we accept the formula that without a transgression there is no access to *jouissance*, and, to return to Saint Paul, that that is precisely the function of the Law. Transgression in the direction of *jouissance* only takes place if it is supported by the oppositional principle, by the forms of the Law. If the paths to *jouissance* have something in them that dies out, that tends to make them impassable, prohibition, if I may say so, becomes its all-terrain vehicle, its half-track truck, that gets it out of the circuitous routes that lead man back in a roundabout way toward the rut of a short and well-trodden satisfaction.[23]

The specific Lacanian inflection of the 'problem of law' has shifted in an important way by the time we get to the post-1968 discussion of the Other in psychoanalysis and indeed has shifted in keeping with the same shift in logics that marks Pasolini's anxiety about 1968 as a more effectively fascistic power than 1938. The latter intervention from 'the other side of psychoanalysis' ends, rather, with a repetition of the initial suggestion that 'analysis shows' us power structures marked not by *transgressions* but by *detours* of power. This shift in focus is perhaps flagged best by the invocation, at the beginning of the latter seminar, of a world *without transgression*. The concepts are not entirely new, but inflected differently. Indeed, Lacan refers to 'an experience' which his theoretical models repeat in a different mode.[24] This experience is, in turn, in keeping with a sense that what he calls 'the master's discourse' effectively co-opts opposition because it has 'needed to go beyond certain limits' in order to maintain the aura, the authority, the effectivity of its 'name'.[25] This transformation beyond 'limits'

23 Jacques Lacan, *The Seminar of Jacques Lacan: The Ethics of Psychoanalysis (1959–1960)* (New York: W. W. Norton, 1997), 1177.

24 Jacques Lacan, *The Other Side of Psychoanalysis: The Seminar of Jacques Lacan, Book XVII*, trans. Russell Griggs (New York: W. W. Norton and Company, 2007), 164.

25 Ibid., (167f) after the extract.

Afterword

which themselves constituted the recognizability of the master–slave dialectic Lacan calls a 'capital mutation ... which gives the master's discourse its capitalist style'.[26] Put differently:

> In the master's discourse, for instance, it is effectively impossible that there be a master who makes the entire world function. Getting people to work is even more tiring, if one really has to do it, than working oneself. The master never does it. He gives a sign, the master signifier, and everybody jumps. That's where you have to start, which is, in effect, completely impossible. It's tangible every day.[27]

Consistently within the later writings of Lacan, the more pressing issue is that paradoxically – with the disappearance of the sovereignty of the lawgiver or the big Other – there is a *proliferation of the modes of control whereby a virtual Other might anchor itself*. As she puts it in her excellent discussion of the radical immanence of a desiring economy – which she glosses, through Spinoza and Lacan alike, as 'secular causality' – A. Kiarina Kordela writes: 'To say that the subject is the cause of itself amounts to the assertion that *everything* can be the cause of the subject, under the precondition that the subject "agrees" that this is its cause.'[28]

Differently put, it seems *at just this point* that the problematic appears which inspired Lacan to reverse the anxiety of 'old father Karamazov' about the death of God, inasmuch as (the old father believed) the death of the divine sovereign would mean that 'everything is permitted'.[29] If the sovereign (divine) monarch, the

26 Ibid., (168) after the extract.
27 Ibid., (174) after the extract.
28 A. Kiarina Kordela, *$urplus: Spinoza, Lacan* (Albany, NY: SUNY Press, 2007), 38.
29 Lacan, *The Other Side of Psychoanalysis*, 119f.
By the end of her article Marie-Clare Boons would even give us to understand that many things flow from this death of the father and notably a

paternal law which functions as the system's fulcrum, leverage point, or external ground is removed – Lacan countered – then the problem is rather that *nothing is permitted*. Without the external measure of repressive prohibition, how would one even distinguish between mewling subservience and bold transgression, and in relation to what structure of power? Rather than the link to Romans 7, perhaps here the intriguingly retroactive textual connection to make would be to point out that it is Paul who opposes grace/faith and work/law in order to demonize the law in Galatians (as enslaving, as a curse, as given by questionable angels rather than by God, as mere calculation, and so on), only to turn around in Romans to declare: 'Do we overthrow the law by faith? No way. Rather, we uphold the law' (Rom. 3:31). The constellation of Pauline contradictions is intriguing in the sense that Lacan's problem here is the way the *withdrawal* of a localizable, representable prohibition only makes it possible for a massive influx of other forms of coercion and mastery, all of which can appear (retroactively) to have played the role of cause. As Lacan puts it, such is the 'capitalization' of the (earlier) role of the 'master'.

As the Karamazov story and its Lacanian inversion imply, the collapse of an 'outside' position from which power is exerted (but also in terms of which power is sheltered, preserved, saved) cuts loose an explosion of indeterminacy and ambiguity about power and its contestation. And just here, between the utter loss of a site of resistance and a paradoxical explosion of new life, appears Pasolini's Paul. At any rate, Lacan believed that the new economies of power precluded anything like a Christian or post-Christian 'good news' of the *overcoming* of the order of law, particularly as an anarchic freedom, as it were, beyond the law. As he quips, 'It is certainly not as an attempt to explain what sleeping

certain something that would make it the case that in some way psychoanalysis frees us from the law ... Fat chance.' (119)

with the mother means that the murder of the father is introduced into Freudian doctrine.'[30] Put differently, the promise of analysis is certainly *not* that 'in some way psychoanalysis frees us from the law'.[31] Indeed, it is difficult not to hear echoes of a comparison between Paul and Oedipus when Lacan describes Oedipus as having transgressed the limits of power or *nomos* only to discover that without these limits he has no buffer between himself and the *lack of power*, which constitutes power as such. In Oedipus's conversion, so to speak, to a life beyond law, 'what happens to him is not that the scales fall from his eyes, but that his eyes fall from him like scales … In other words … the essence of the master's position is to be castrated.'[32]

Stranded between 1938 and 1968, forced to reconceptualise power and emancipation in a world without the legitimation of founding origins or assured ends, Paul returns as an indication of a world in which power increasingly resides in the surplus or excess over the representational. Pasolini's Paul returns as both the herald of radical openings, ecstasies of new ages always about to appear, but just as much as the threat of foreclosure of the open. No wonder Pasolini sometimes imagines the author of Acts, that first soporific institutional co-optation of a singular Pauline partisanship, to be a satanic figure. But the relation between the production and consumption of excess within neo-capitalist contexts is not simply about the relation of the partisan to the institution. Perhaps the real secret of power in the age of mastery's 'capitalization' is the way it is as if power's own weakness were the most effective form of conjuring ritual supplementation and an investment of credit or faith from ritual adherents (whether transgressive or subservient would make no difference). And with this gesture the

30 Ibid., 120.
31 Ibid., 119.
32 Ibid., 121.

ancient-and-returned Paulinism in question forces a stark splitting of political options. After all, in an age of the capitalization of mastery, one either participates in the ritual maintenance of the powerless master or risks a more direct negotiation of the very powerlessness of all mastery itself.

On the Typeface

Saint Paul is set in Monotype Fournier, a typeface based on the designs of the eighteenth-century printer and typefounder Pierre Simon Fournier. He in turn was influenced by the constructed type designs of the Romain du Roi, commissioned by Louis XIV in 1692, which eschewed the calligraphic influence of prior typefaces in favour of scientific precision and adherence to a grid.

With its vertical axis, pronounced contrast and unbracketed serifs, the Fournier face is an archetype of the 'transitional' style in the evolution of Latin printing types – situated between the 'old style' fonts such as Bembo and Garamond and the 'modern' faces of Bodoni and Didot. Other distinguishing features include the proportionally low height of the capitals and the lowercase 'f', with its tapered and declining crossbar.

The italics, which were designed independently, have an exaggerated slope with sharp terminals that retain the squared serifs in the descenders.

The Fournier design was commissioned as part of the Monotype Corporation's type revival programme under the supervision of Stanley Morison in the 1920s. Two designs were cut based on the 'St Augustin Ordinaire' design shown in Fournier's *Manuel Typographique*. In Morison's absence, the wrong design was approved, resulting in the typeface now known as Fournier.